CAPTURING NATURE IN WATERCOLOR

PHILIP JAMISON

CAPTURING NATURE IN WATERCOLOR

WATSON-GUPTILL PUBLICATIONS / NEW YORK
PITMAN PUBLISHING / LONDON

First published 1980 in the United States and Canada by Watson-Guptill Publications,
a division of Billboard Publications, Inc.,
1515 Broadway, New York, N.Y. 10036

Library of Congress Cataloging in Publication Data
Jamison, Philip, 1925–
 Capturing nature in watercolor.
 Includes index.
 1. Water-color painting—Technique. 2. Landscape
painting—Technique. I. Title.
ND2240.J32 1980 751.4'22 79–23947
ISBN 0–8230–0558–5

Published in Great Britain by Pitman Publishing Ltd.,
39 Parker Street, London WC2B 5PB
ISBN 0-273-01513-3

Manufactured in Japan

First Printing, 1980

2 3 4 5 6 7 8 9/86 85 84 83 82

*Dedicated to Jane, Terry, Linda, Flip
and, of course, Daisy*

Contents

PART ONE

INTRODUCTION

Personal History and Philosophy

Horace Pippin, one of the world's foremost primitive painters, once wrote that art cannot be taught. He was probably referring to the creative aspect of painting, which is what "separates the men from the boys." It makes the difference between a good painting and a bad one; a masterpiece and a merely competent piece of art. Pippin was right—in this sense, art *cannot* be taught.

Pippin, a black artist who lived and painted in my home town of West Chester, Pennsylvania, was a very powerful painter. His statement applies particularly well to his own work: he was a self-taught naive painter and he expressed himself in a style that was uniquely his. Turned off by the thought of taking lessons, he never attended art school. In terms of his own work, he was correct. Pippin's artistic brilliance would have been squelched had he studied under others or taken formal art training. His was an art that came completely from within, without the need for any outside assistance.

However, most artists are not primitive painters and are not in the genius category. While creativity cannot be taught, the great majority of painters—through training, study, and the process of painting itself—can acquire a tremendous amount of knowledge, understanding, and technical skill. The secret to both improving your skills and attaining higher esthetic standards is to follow the correct path of instruction and study.

Too often, especially in our innocent, youthful enthusiasm, we follow the wrong leader. This was certainly true in my case. It was not until several years after I had graduated from art school that I discovered that I had been looking at art with half-closed eyes.

My earliest recollection of my interest in art is of a gingerbread man I drew when I was in the first grade. Next I remember a Buck Rogers–type rocket ship that I sketched with colored pencils at about the age of nine. Later, in junior high school, I won a small silver trophy for a Mongol pencil drawing of a dancing lady. I was very proud of the trophy, but never liked that particular drawing because my teacher, in trying to be helpful, had worked on it, and I felt it reflected his ideas more than my own.

When I was growing up, drawing and painting were just

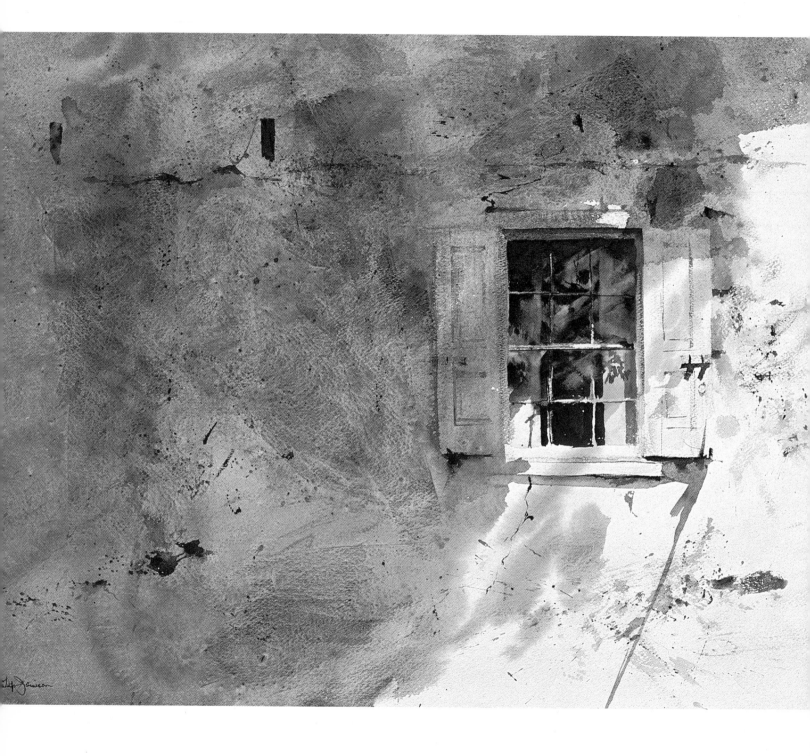

The Window
Watercolor
21¼″ x 28¾″ (54 x 73 cm)

One day in 1959, I sat outside in the summer shade and painted this window of what is now the Dilworthtown Inn, just south of West Chester, Pennsylvania. In those days I did practically all of my painting outdoors and on location. This one was painted very directly in pure transparent watercolor and was completed in perhaps less than two hours. Reflecting on those carefree outdoor excursions, I recall how uncomplicated my thinking was. On the spur of the moment I would simply gather my gear together and go out and paint. Now, twenty years later, with many learning experiences under my belt and my outlook on art considerably changed, I find that my thoughts churn over and over in my mind many times before I put a brushstroke on the paper.

plain fun to me. My mother was always most encouraging and supplied me with whatever art materials I desired. However, I must admit that art was not in the least bit all-consuming to me. I was busy with all the other interests that an active boy usually has.

Throughout high school I was enrolled in the college preparatory course, but I also found time to take two art classes each day, simply because I enjoyed it. My art teacher during those days was William Palmer Lear, who was not only a very entertaining man but also a respected leader of the young people in our community. Unquestionably Bill Lear had a great influence on my interest in art and on my life in general. I had known him since I was a tiny boy, and at the age of eleven had joined the Boy Scout troop of which he was scoutmaster. My parents had separated when I was four, and I was raised by a very wise and loving mother. It was not until I was sixteen that I saw my father again. For this reason I fondly remember the day when, in the junior high school hallway, Bill Lear put his arm around my shoulder and offered to be a "second" father to me. It was a promise that he kept.

As I look back on my life I realize, with some astonishment, that I was never encouraged to pursue art as a career. My youthful years were full and happy ones, and, perhaps because my own attitude was that art was "just plain fun," no one ever suggested that I go to art school or further my education somewhere in the realm of the arts.

All through school I planned to attend the University of Pennsylvania, study economics, and eventually go into the real estate business. Undoubtedly I was influenced by the fact that real estate was my father's profession, but I also had—and do have to this day—a keen interest in it. I still have, pinned to my studio wall, my formal application for admission to Penn, along with my high school transcript—souvenirs of plans that changed unexpectedly.

At first it seemed that my goals were simply delayed. Within three months of my graduation from high school in 1943, I was drafted into the armed forces, and so I had to postpone college. Having just completed high school courses in physics, chemistry, and elements of electricity when I entered the service, I scored well on a Naval aptitude test. For this reason, I spent

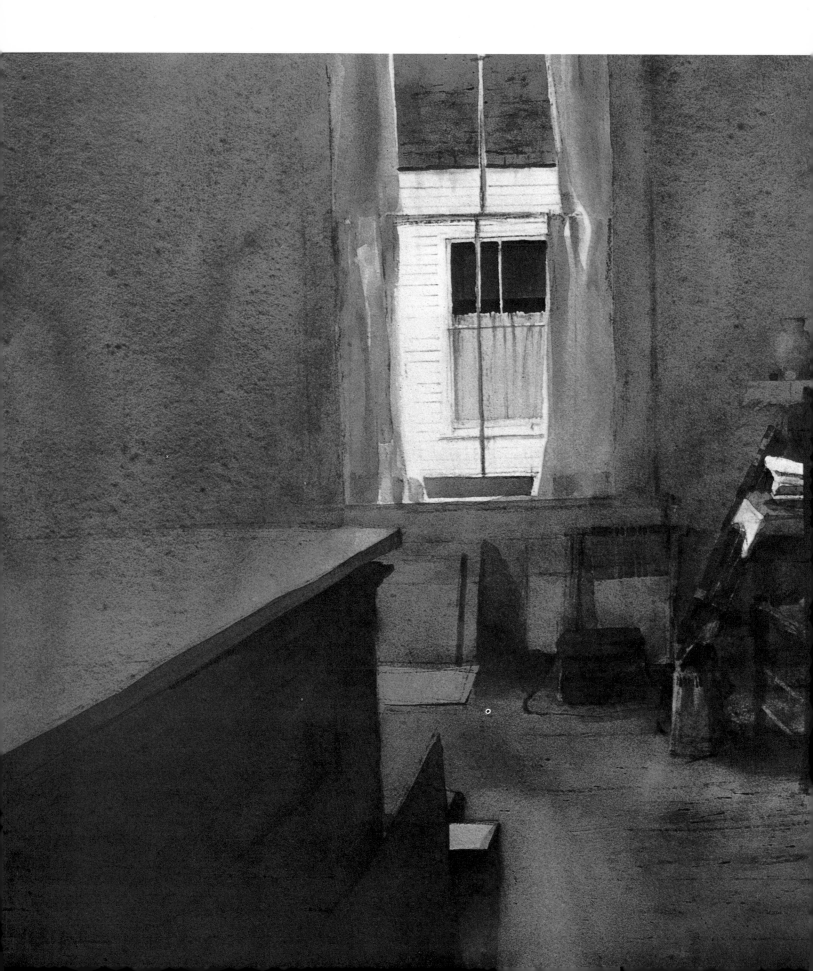

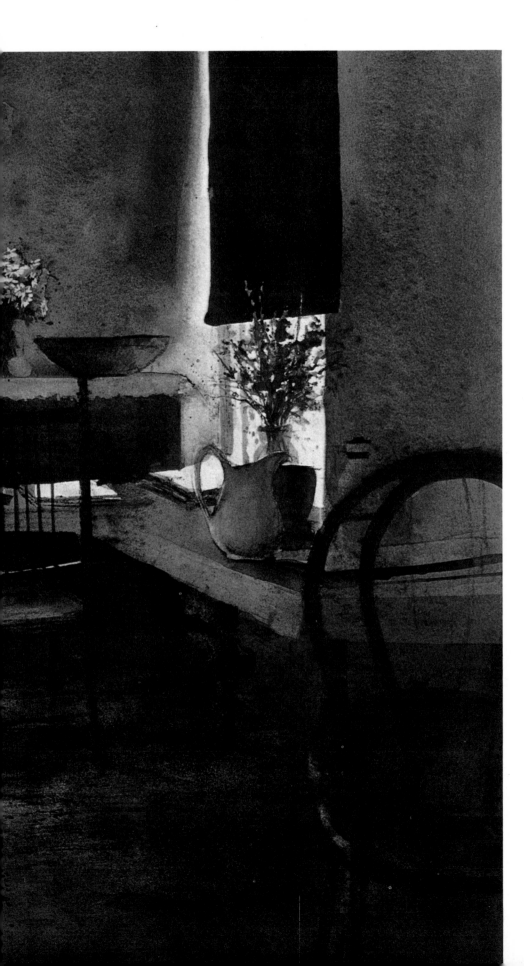

Floss Mullin's Window
Watercolor and charcoal
18½″ x 28¾″ (47 x 73 cm)

This painting is of a corner of my studio in Vinalhaven, Maine. Its title is derived from Floss Mullin's shed window, which is visible outside the studio. Floss was a dear, sweet, dignified, and independent little lady who was our neighbor on the island for some years. To me she typified the straightforwardness and goodness of native Maine people. In 1976 this watercolor was exhibited at the Metropolitan Museum of Art in New York City, in the show Two Hundred Years of Watercolor Painting in America. The exhibition commemorated the centennial of the American Watercolor Society.

most of my two and a half years in the Navy studying electronics—which, incidentally, I deplored! My art took a back seat during this period, though I often drew cartoons for the local Navy news sheet, and my letters home were embellished with cartoon-type drawings of my escapades.

When I returned to civilian life, I again pursued my plans to attend college. But with the flood of returning servicemen, college admission applications were soaring. Although I had already been accepted at the university, I was informed in late summer of 1946 that I could not begin classes until 1947.

During that period, when I had time on my hands, an art student of my acquaintance suggested, "Why don't you go to art school?" This possibility had actually never occurred to me. But the more I tossed the idea around, the more attractive it became. In fact, I liked it a great deal. But in order to be certain I was making the right move, I consulted several older people whose opinions I respected, hoping they could advise me. Willingly they lent me their ears, but in no way could they—or would they—make such a decision for me. It had to be up to me. So I weighed art school against college, the arts against business, and, after much soul-searching, enrolled at the Philadelphia Museum School of Industrial Art (now the Philadelphia College of Art).

As a teenager I had been keenly interested in decorating our house, and my mother had always allowed me to do all the planning, painting, and furnishing of the rooms—everything from covering one entire wall with a mural to building my own bed. And so I imagine it was for this reason that I chose to major in interior design—a decision that was the beginning of a long-continuing effort to find myself in art.

After I had begun taking some courses in drawing and painting, along with my interior design courses at PMSIA, I found myself becoming increasingly drawn toward painting. And so, after two years as an interior design student, I changed my major to illustration. This switch may also have been partly due to my "second" meeting of Jane Gray, a fellow student attending PMSIA. We had been childhood friends many years earlier, but our paths had seldom crossed during the intervening years. Now I found that Jane, whom I would eventually marry at the conclusion of art school, shared my enthusiasm for painting.

Chester County Courthouse
Watercolor with traces
of charcoal and pastel
14" x 19¼" (35.6 x 48.9 cm)

West Chester is steeped in fine architecture, which I delight in painting. The Chester County Courthouse, topped by its copper-clad town clock, was designed by Thomas U. Walter, the architect who designed the dome on the Capitol building in Washington, D.C. When I paint street scenes like this one, I start out with large, bold washes and then build up with successive layers, employing detail only where I feel it is needed and merely suggesting the rest.

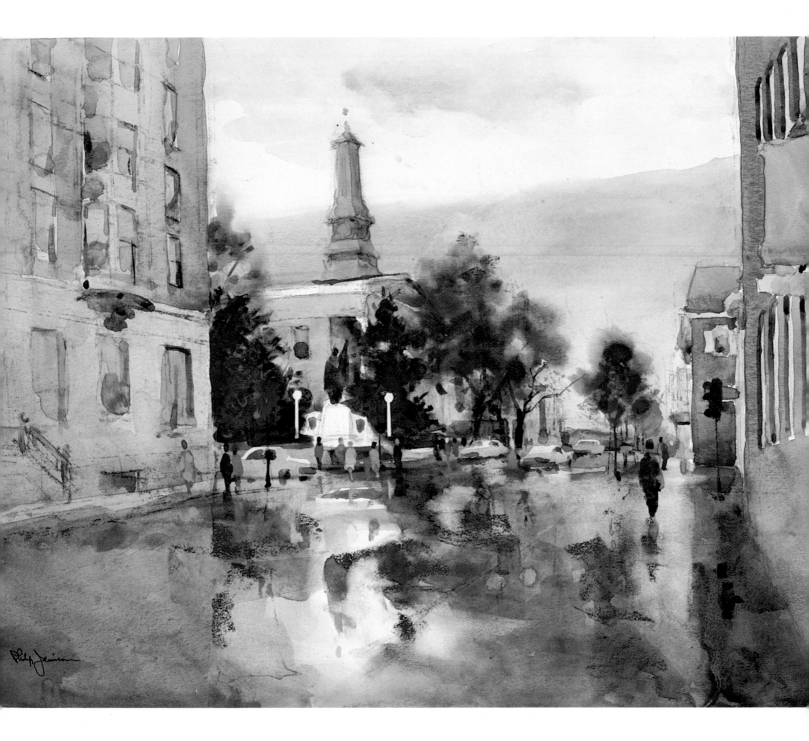

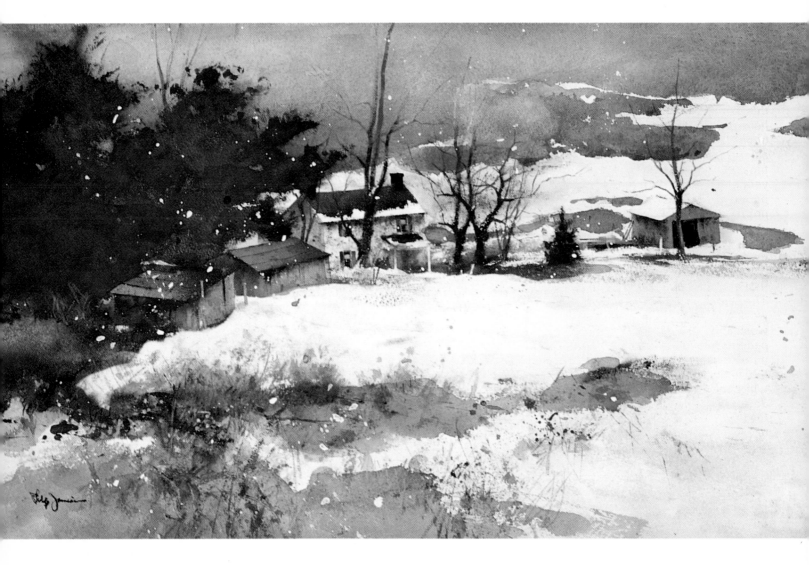

Goodwin's
Watercolor
12½″ x 23″ (31.8 x 58.4 cm)

Because of sheer neglect, very little, if anything, now remains of this picturesque old farm that I have painted several times since about 1967. This particular watercolor has been reworked several times over a period of twelve years, so much so that the 140-pound paper on which it is painted is almost completely worn through in spots. Of the many changes I made, perhaps the most dramatic was in the upper third of the paper. Originally that area contained hills and sky. The overall design just did not work to my satisfaction, so I washed it out and simply continued the field to the very top of the paper. I also gave special attention to the shapes of the large white snow areas, as well as the dark pines, and several times during the course of painting, I altered both drastically.

Jane was also majoring in illustration, and together we met and studied watercolor under W. Emerton Heitland, a prominent watercolorist and illustrator who also taught at the school in those days. I remember his watercolors as being fresh, colorful, and filled with the exuberance of the medium. A small group of students, including Jane and myself, were particularly intrigued by watercolor as a medium, and our mutual interest became mutually inspiring as well. It was under the guidance of Bill Heitland that my own watercolor paintings began to develop. However, it was his keen interest in his students after graduation from art school, rather than in class, that was to be especially beneficial to me. During my early, formative years just out of school, he became my guide and advisor. If I wanted a criticism, he would willingly oblige. When I needed advice on how and where to exhibit my work, he was always handy. And, perhaps most importantly, he was a friend.

For a short while after graduation I dabbled in the illustration field, but I found the work too restricting to suit my nature. I did not enjoy illustrating someone else's story or idea; and the constant research that illustrating required was, to me, very boring. I kept returning to watercolor, painting *what I wanted, the way I wanted.* Jane and I went out on weekends and at every other opportunity to paint watercolor landscapes. At last I had found what I had long been searching for.

My mother had written and published a small book about making lampshades. With her assistance and my interior design background, Jane and I decided to set up a small business designing and making custom-made lampshades, chiefly for interior designers in the Philadelphia area. At the time we had a second-floor apartment in my mother's home, and our largest room doubled as a studio and a "lampshade factory."

As exciting as the medium of watercolor had become for me, I did not yet realize that my education had one large, gaping omission—art appreciation. In addition to art history courses, which I usually found to be dull, I had been taught all of the technical aspects of painting, all of the currently popular illustration and advertising styles, and who the fashionable "names" of the commercial world were. But although I didn't realize it at the time, I did not understand what fine art was all about.

It was in the late 1950's that Robert McKinney, a painter and professor of art at West Chester State College, came into my life, and an entire new world of art opened up to me. Although I no longer recall our initial meeting, I do know that we immediately became friends. And for many years since, we have enjoyed countless discussions about art. Although Bob Mc-Kinney paints in a completely abstract style, he would give me monthly critiques on my realistic watercolors. He both encouraged and inspired me. His vast knowledge and effervescent interest in all forms of the arts, from painting to architecture to fashion design to ballet and the orchestra, couldn't help but rub off on me. It was through him that I became aware of watercolorists such as J. M. W. Turner and Maurice Prendergast. My eyes began to open up to truly good art.

My interests turned away from the fashionable, gimmicky, slick techniques that I had idealized earlier to the more creative, enduring paintings that I so appreciate now. Of course, as one studies, one grows. The things I admired in my youth seemed shallow in retrospect and no longer held my interest. My new influences became artists like Odilon Redon and Edward Hopper.

Although the French artist Redon was noted for his strange, sinister visions in black and white, during the last years of his life he also did the most beautiful paintings of flowers ever created. Redon was not really a watercolor painter—his great flower paintings were done in both oil and pastel—but the medium in which a painting is done makes little difference to me. Although I have seen many of Redon's paintings, the memory of one especially lingers in my mind. I was traveling through Arizona on my way to the West Coast when I stopped to visit the Phoenix Art Museum. When I rounded a corner and saw a Redon, I was overwhelmed by its beauty. There is a "rule" in painting which states that one can't improve on nature, but Redon disproves this. His paintings are not imitations of nature at all, but rather nature interpreted through the eyes of a creative genius—an artist with a color sense second to none.

Edward Hopper had a superb command of several media, including watercolor. He painted the cityscapes and landscapes of America with a new fervor, and with a simplicity that is utterly amazing. Although creative composition is a

Amy
Watercolor
13⅛" x 15⅜" (33.3 x 39.1 cm)
Collection of Mr. and Mrs.
Charles J. Upperman

About 1958 I painted a commissioned watercolor of The Old Mill restaurant for the Upperman family near West Chester. While stopping by to visit them briefly at their home, I was captivated by their young daughter Amy, who was playing in the yard. I guess I've always been a pushover for a little girl with ribbons on her pigtails. Her subtle little face against the dark blue shirt accented by the bright red ribbons was almost too pretty to paint. However, I did paint her, and managed to achieve just what I wished to express. I wanted the shape of the figure to be unobtrusive, so I used a strong dark, which flows from the top of the head to the bottom of the painting. All of the elements are painted in a simple manner, especially the shirt and the child's arms, which are reduced to two nearly flat values but at the same time suggest rounded form. The color relationships and the negative shapes are probably more important in a portrait than any other type of painting because the general composition is usually more conventional and therefore limiting. So in this respect, the background plays a very important part, even though it is of secondary interest. I chose to compose it of neutral colors, which would complement the figure and at the same time give the feeling of space. The textural quality was achieved by rubbing a sponge over the watercolor and charcoal base.

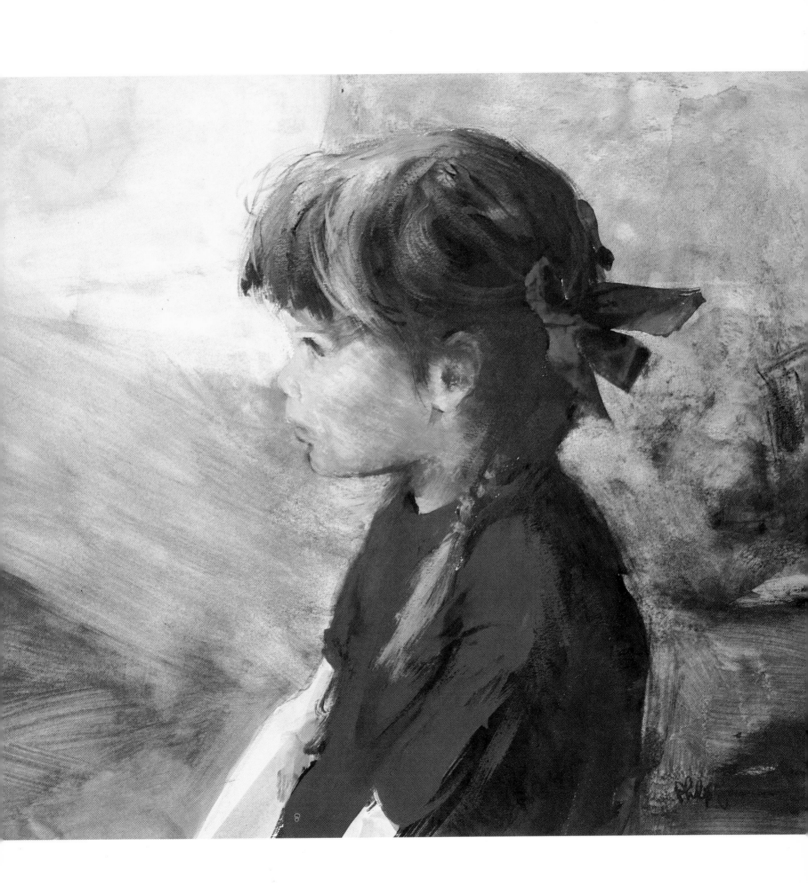

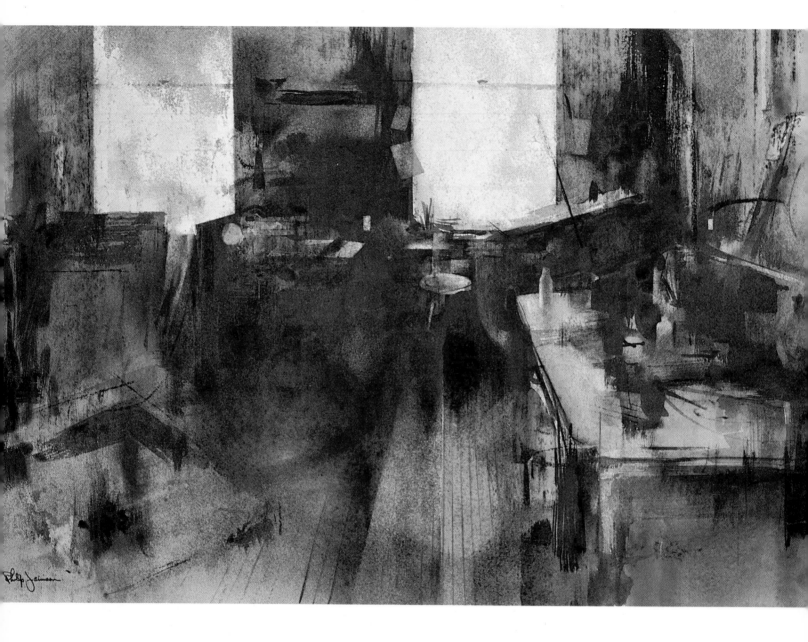

Studio
Watercolor and charcoal
13¾″ x 21″ (35 x 53 cm)

In the late fifties, as I experimented more with using watercolor and charcoal together, I found the forms in my paintings becoming more and more simplified. It also seems that as I reduced my subject matter to near abstraction, my color was likewise reduced almost exclusively to neutral tones. This painting of my first studio is almost completely abstract. Although I painted it directly from life, my interest was not in the subject matter as such but in the shapes and color. I used a basically neutral palette, but I feel very strongly that a painting can have "color" without using bright colors.

subject that I feel is almost impossible to teach, only a brief study of Hopper's paintings and drawings will show the serious student that Hopper was a master of design. His compositions are some of the most powerful that have ever been conceived.

Hopper's sense of design is also embodied in another watercolorist's work—that of Andrew Wyeth. The first thing you notice about a Wyeth painting is its strong black and white pattern. Even when Wyeth delves into intricate detail, it is all built upon a bold, abstract framework.

When I was in high school, Bill Lear told me that "simplicity is the keynote to modern art." For some reason I remembered the phrase, and as the years have passed, I've come to the conclusion that simplicity is the keynote not only to modern art, but to all art. *Simplicity* in this sense denotes, not a lack of detail, but rather, clarity of thought and concept. In a Wyeth painting each blade of grass may be visible, but the basic design that carries it is an uncomplicated one. This is also true of the work of Maurice Prendergast, whose beach and bathing scenes are among the most complex watercolor compositions ever painted. Although a Prendergast watercolor sparkles with detail like a carpet of jewels, the simplicity of the idea unifies the painting.

If you ever have an opportunity to see the watercolors of J. M. W. Turner, don't miss it. Early in the nineteenth century, Turner and his fellow Englishman, John Constable, were instrumental in developing watercolors into finished works of art; up to that time, the medium had been used primarily for preliminary studies. They were also among the first to paint outdoors, directly from nature itself, rather than in the studio. Although Turner is best known for his oil paintings, it is his fresh, fluid little watercolors that fascinate me most. His skies are filled with light and air, and he was one of the few watercolorists who could paint a sunset without making it appear trite or gaudy. No doubt Turner was ahead of his time. His freer, more experimental use of watercolor was almost abstract, and some of his paintings consisted of not much more than light and air painted in a rainbow of harmonious hues. But oh, how he could translate that light and air into paint on paper! He painted atmosphere as no one has painted it before

or since; and, largely because of his later atmospheric, almost nonobjective canvases, some authorities today consider him to be the founder of modern art.

It was the American painters, however, who developed watercolor into a full-fledged medium to be taken seriously in its own right. The Pennsylvania Academy of the Fine Arts, the oldest art school in the United States, exhibited English watercolors during the period from 1816 to 1860, and was instrumental in promoting the growth of the medium in this country. The founding of the National Academy of Design in New York City in 1825, and of the American Watercolor Society in 1866, also greatly furthered the cause of watercolor painting.

It was around this time that John James Audubon painted his masterful watercolors of birds which have inspired a host of imitators, none of whom have been able to match his talents. Audubon's bird studies were published in four double-elephant folios titled *The Birds of America.*

During the second half of the nineteenth century, Winslow Homer, beginning as an illustrator, was painting fresh, sparkling, pure watercolors of American scenes. His paintings may have been the greatest influence on aquarellists since that time.

After Homer we have had a wealth of great American watercolorists, among them John Marin, whose very personal abstract style has become synonymous with the word *watercolor.* Others of outstanding importance include Charles Burchfield, Charles Demuth, Paul Sample, Dong Kingman, and Chen Chi. Many of these artists have influenced me esthetically, as well as many, many others who were not particularly connected with the medium of watercolor.

Gradually, as I began to sell my watercolors, I spent more and more time painting. Around 1958 I was approached by both the Hirschl and Adler Galleries in New York City and the Philadelphia gallery Charles Sessler, Inc., asking me if I would be interested in having them handle my work. Naturally, I was delighted. And so Jane and I, after being out of art school for eight years, made the decision to give up our lampshade business and devote our energy exclusively to painting. Since that time, I have been a full-time painter. Although I have exhibited widely throughout the United States, most of my major

Along Hillsdale Road
Watercolor
8½″ x 11¾″ (21.6 x 29.9 cm)

This small watercolor was painted several years ago and remains one of my personal favorites. It is quite unassuming and there is nothing particularly daring or obvious about it; yet, of all the paintings I have done, it is among the few that I enjoy the most. Each year American Artists Group, Inc., of New York City, reproduces one of my paintings on a Christmas card, and this painting was once selected.

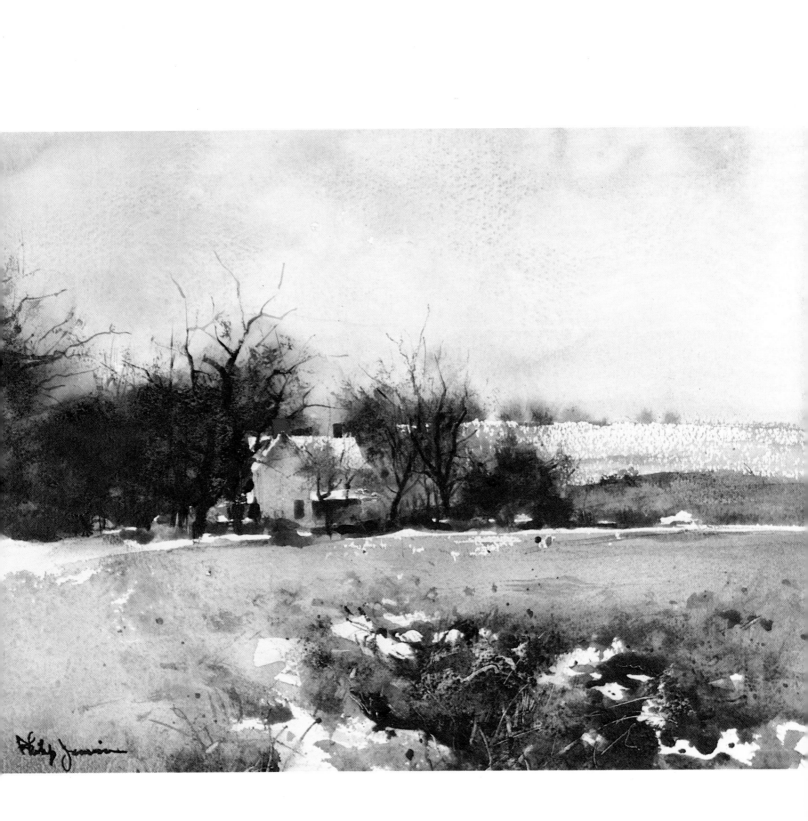

one-man shows have been held, at two-year intervals, at the Hirschl and Adler Galleries in New York. I have continued, of course, to live and paint in West Chester, Pennsylvania, where I was raised. Over the years my painting subjects have remained generally the same—our town, the surrounding landscape, and flowers. But, although my subject matter has not changed significantly, I believe that my feeling for it now runs much deeper than it did a decade or so ago.

Because all of my ideas are derived from nature and are presented in a realistic manner, I label myself a Realist. However, this does not mean that I copy nature. I paint the things that I know and am familiar with—primarily the landscapes and flowers of Pennsylvania and Maine, where I live in the winter and summer, respectively. Occasionally I do a painting that is quite faithful to its subject, but in most cases I take great liberties in changing almost anything that I see before me if it will enhance my composition or idea. In fact, my paintings often change drastically as I work on them—sometimes to the extent that a figure painting may well end up being a painting of flowers! My subject is secondary to the *feeling* with which I paint it.

I approach almost all paintings as abstractions, with the overall pattern or design being paramount. In this respect, I was greatly influenced by the Abstract Expressionist movement of the late 1940's and early 1950's. During this time I found the work of Adolph Gottlieb, Franz Kline, and other abstract expressionist painters exciting, and I began to look at my own paintings in the same way I looked at theirs. Nevertheless, as dynamic as these artists were, I felt that in order to satisfy my own inner convictions, I needed some reference to nature in my own work. For me, totally nonobjective painting can often, though certainly not always, lack depth—whether it be visual, esthetic, intellectual, or emotional. In fact, as I view the Abstract Expressionists' canvases today, I feel they've lost a great deal of their original impact for me; many, perhaps, remain more historically than esthetically significant.

For a number of years I painted all of my watercolors on location regardless of the weather. I have painted in snow, fog, and rain, and enjoyed it. Recently, however, as I take more and more time to complete a painting and make many changes as

the painting progresses, I find that the elements have become an inconvenience. Consequently, I now prefer to do most of my work in the studio, where I have complete control over the light and atmospheric conditions.

Previously a watercolor done on location was completed in two hours or so, but now I may work on a picture over a period of as long as two years—always attempting to "finish" it. When I take a long time with a painting, it is usually because I am either trying to strengthen the composition or to simplify various elements. Often the finished painting is quite different from my original idea. Fundamentally, what I am trying to achieve is a happy union of subject matter and feeling. Sometimes it comes easily. Usually it doesn't. I have heard it stated, "Some artists pull paintings out of their pockets. I pull them from my gut." I know just what that means.

Studio and Materials

STUDIO

An artist's studio is very personal and should reflect his own needs as far as painting is concerned. I have a background in interior design and an intense interest in architecture, but in no way do I want my studio to be a showplace. It would be too sterile and would inhibit my ability to work. By the same token, I don't want to work in complete chaos. And so the kind of studio I prefer is one that is comfortably functional.

I actually have two studios: a winter studio in West Chester, Pennsylvania, where I live for the major part of the year, and another in my home on the island of Vinalhaven, Maine, where I spend the summer. The Pennsylvania studio is necessarily larger and more complete than my studio in Maine, since I spend most of my time there. It is divided into three major areas.

Work Space. The room where I do my painting consists of two areas. One is the painting area, which contains my watercolor tables and painting equipment, a sink, an easel, and a pin-up wall for sketches and miscellaneous items of current personal interest. The greatest asset of this room is a large expanse of north windows which give me consistent cool light all day long. The walls and ceilings are painted white to minimize reflected colors that might interfere with the color of my paintings.

Storage and Reference. The second area of the room harbors my flat files for storing watercolor paper, a small library, floor-to-ceiling racks that contain framed paintings, and a chair or two for reading. In addition to this room I also have a small office in which I do my bookkeeping and maintain my files.

Framing Area. A third room, where I do my matting and framing, contains a 4′ x 8′ work table, more storage racks, and a small space in which I do any necessary photographic work.

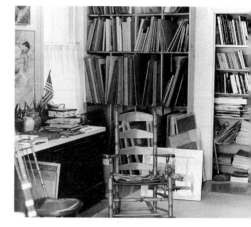

One corner of my Pennsylvania studio, above, is devoted to storage: it has a flat file containing watercolor papers, a storage rack for paintings, and a book closet. The working area, above right, is situated to take advantage of consistent, cool light from the north windows. The matting and framing room, below right, contains a long work table as well as a camera set-up for photographing my paintings.

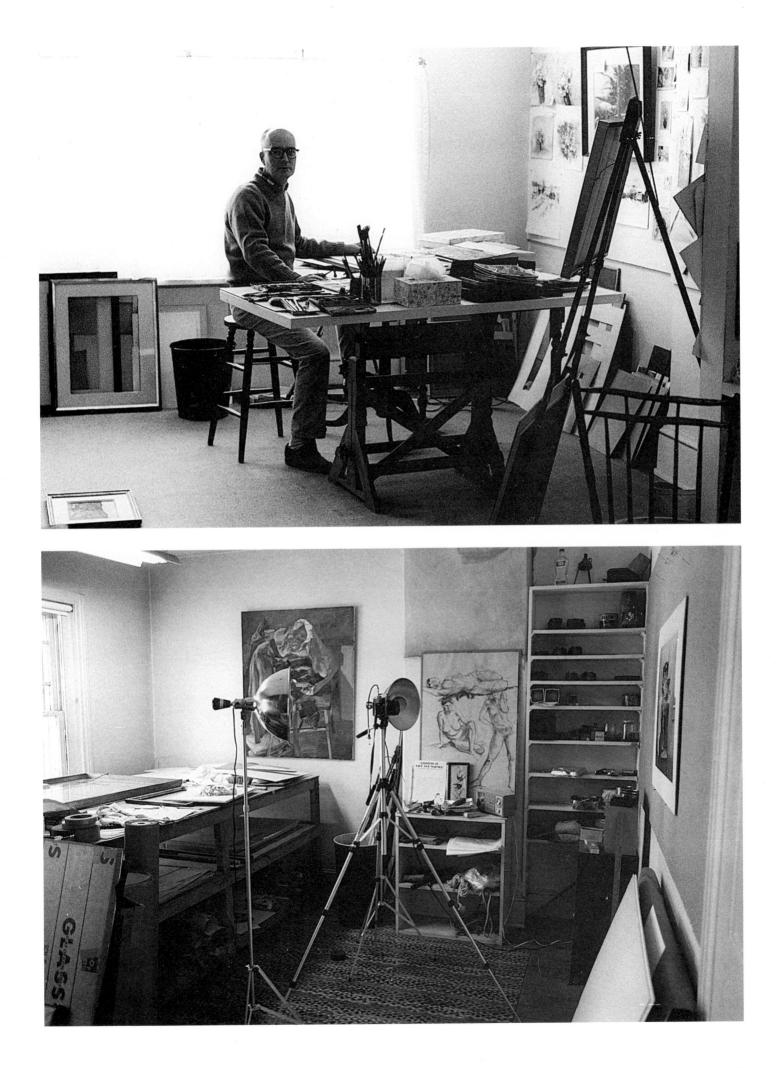

EQUIPMENT

My own needs dictate my choice of painting gear. What appeals to me might not necessarily suit another artist. I like to keep my equipment simple, and any improvements seem to grow naturally.

Work Surfaces. When painting indoors in my studio, I like to work on a drawing board mounted atop a three-legged iron pedestal stand. It has a tilt-top that allows me to instantly adjust the slope of my working surface to any angle in order to control the flow of water on the paper.

Painting Gear. Next to my drawing stand is a much larger table on which I keep all of my painting gear. I seldom go for gadgets and only occasionally add a new piece of equipment. My aluminum watercolor box, which contains china trays for my paints, is the same one I purchased for a dollar and a half when I entered art school. A larger tin box, which was originally for oil painting, was given to me by a neighbor some twenty-five years ago, and I find it perfect for my tube paints and brushes. I use a white plastic divided mixing tray for much of my work, along with the tray in the open watercolor box. However, I haven't given up my old habit of using TV dinner trays, which I find very much to my liking, especially for larger washes. For many years I always used two quart-size Mason jars to hold my water, whether I was working in the studio or out in the field. Not long ago a photograph of my studio was printed in a publication. A reader spotted the Mason jars in the photograph and sent me several plastic containers, which he thought would be much more efficient. This is why I now use plastic containers for water instead of the old jars that were once my favorites!

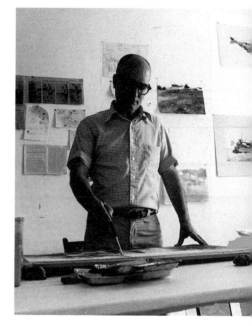

TV-dinner containers make ideal mixing trays, whether I am working in my Maine studio, above, or in Pennsylvania (above right). I also like to use the wall near my painting area for pinning up sketches and notes. Paints, brushes, and other equipment are arranged within easy reach of my painting stand, below right.

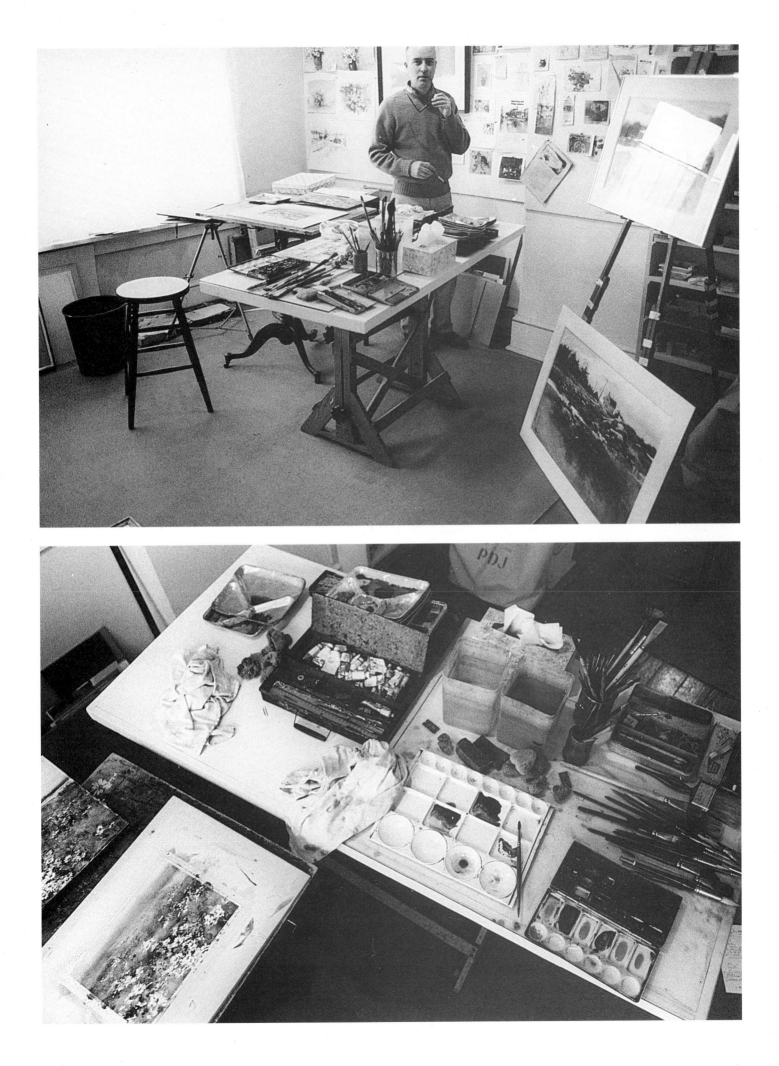

MATERIALS

I usually prefer to use the best painting materials available. No doubt a masterpiece can be done with inferior materials, but why make it difficult? This is not to say that I paint masterpieces, but to emphasize the fact that to skimp on the quality of supplies can be somewhat defeating—especially where brushes and paper are concerned. Conversely, I am often amused by the mountain of trappings amassed by some watercolorists, who seem to have an obsession for buying every gadget that is put on the market.

Brushes. The brushes that I use vary from a small No. 2 red sable to a 2½-inch house-painting brush. I use sizes No. 2, 4, 8, and 12 red sable brushes for most of my general painting other than the larger washes. For these I usually employ a ¾-inch or 1-inch flat wash brush, and occasionally I will use a 2- or 2½-inch house-painting brush. Red sables are certainly my favorites, but because of their constantly escalating cost, I am hopeful that the newer synthetic "sable" brushes being marketed today will be of greater use to artists in the future. During the excitement of painting, and in the attempt to create various textures, I give brushes a great deal of harsh treatment. Perhaps it is because of my Scottish background, but I find it very difficult to punish a sixty-dollar brush!

Basic Palette. Generally speaking, I use an earth-colored palette consisting of about a dozen colors: yellow ochre, cadmium yellow pale, raw umber, raw sienna, burnt sienna, olive green, viridian, Prussian blue, Payne's gray, Davy's gray, Vandyke brown, alizarin crimson, and ivory black. Frequently, I supplement these colors with cadmium yellow, cadmium orange, cadmium red, and mauve; these I use primarily for painting flowers. It is necessary to have strong hues for flowers because these colors cannot be obtained by mixing together colors from my basic palette. Since I have a great penchant for scrubbing out and reworking areas, I try to avoid staining colors that cannot readily be removed.

Paper. I use a great variety of watercolor papers. After years of experimenting with all makes and types of paper, I have yet to find *the* one that suits all of my needs—or, for that matter, even most of my needs. Therefore, I select my paper primarily to

I need an assortment of brushes, above right, to serve different functions in painting a watercolor—from house-painting brushes to fine sables. I use my folding watercolor box, below right, both indoors and out.

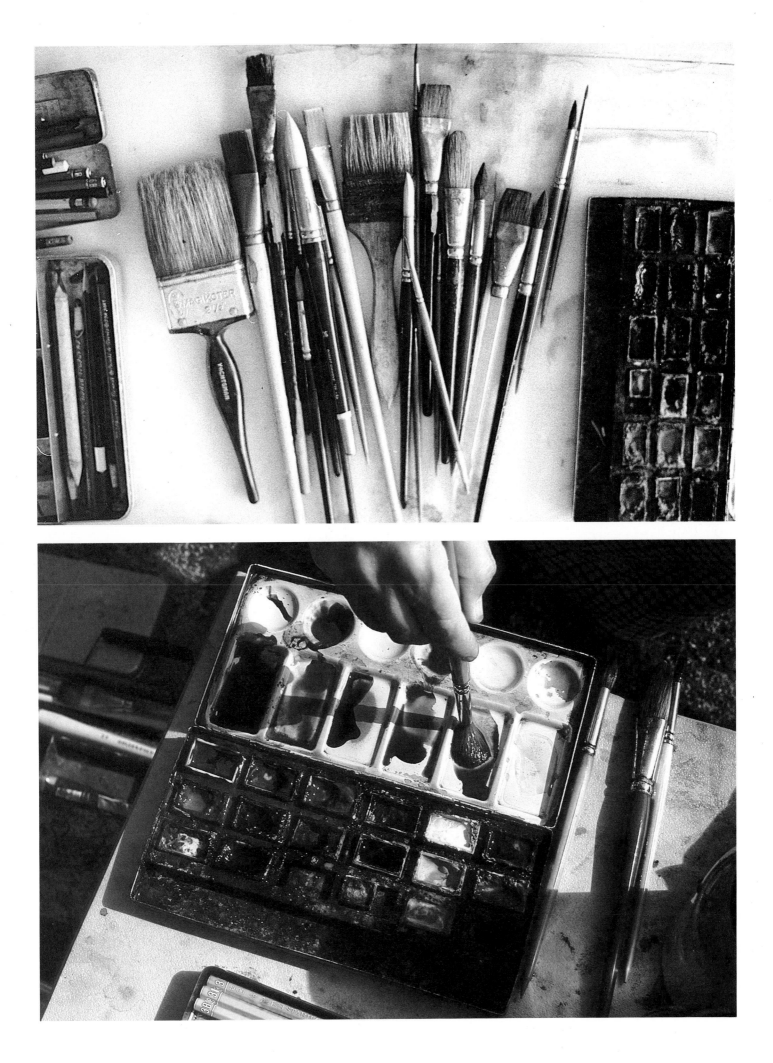

suit the particular type of work I am doing at the moment. For example, a few years ago, when I did a lot of interiors in which I incorporated charcoal work, I preferred a fairly smooth cold-pressed paper mounted on a heavier backing. I also use this kind of paper today for many flower paintings in which I prefer to paint my own textures rather than use a rough paper that creates texture automatically.

Most of my landscapes are done on 100-percent rag paper. Simply because a paper is marked 100-percent rag does not necessarily mean it is of the highest quality. A little-known fact, which was pointed out to me by the president of a paper-manufacturing company, is that the 100-percent rag could be anything from pure linen, which is the highest quality, to garage mechanic's overalls.

The surfaces I use vary from smooth to rough, although I seldom use the very roughest texture. Of course, I favor the handmade papers of better quality, such as D'Arches, but in this category the choice is limited. In recent years some of the old established makers of handmade watercolor paper, such as Whatman, have gone out of business, and today there is a definite need for the manufacture of better grades of really fine acid-free watercolor paper.

I contacted Strathmore Paper Company several years ago and was pleased to hear that they were interested in developing more papers for the serious watercolorist. We had a running correspondence, during which I had the rare privilege of using some of the experimental watercolor papers on which they were working.

For smaller watercolors I often use watercolor blocks, but for paintings over 15″ x 20″ I find that they buckle too much when the paper is saturated. When working on larger sheets of 140-pound paper, I stretch the paper over varnished ⅜-inch plywood boards that are cut half an inch wider than the paper on each side. After wetting the paper, I tape it down with 2-inch gummed package tape. I don't usually find it necessary to stretch 300-pound paper because of its thicker quality, so I simply tape it to a board with masking tape.

Sponges. Next to my brushes, the items I find most helpful are my sponges, both the natural and the synthetic types. The small-grained natural sponge, commonly termed a cosmetic

Natural sponges, a synthetic sponge, a penknife, and razor blades supplement my brushes as painting tools.

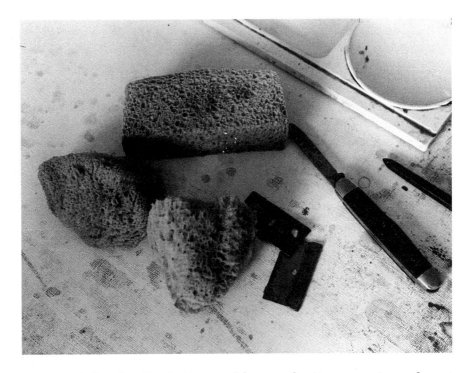

sponge, is by far the better and longer-lasting one. I scrub out both small and large areas with it and, believe me, I use it often. I also employ it for effecting textures in areas such as shrubbery or trees, by simply daubing the sponge in paint and applying it to the painting surface. The man-made photographic-type sponge is handy for wetting large areas of the paper when I want to work wet-in-wet, and also for cleaning my palette.

Other Painting Tools. Occasionally a penknife or a razor blade comes in handy for scraping in suggestions of grasses or small tree limbs. Other than my hands, which I occasionally use as if they were paint brushes, these are about the extent of my painting tools.

Working Methods

MY APPROACH TO PAINTING

Watercolor is a spontaneous medium and lends itself well to my way of working. It dries quickly, it has a fresh, fluid look, and I can work quickly with it. My painting is also more or less spontaneous in that I do little in the way of preparatory sketches. When I see a subject that interests me, I dive right in, usually developing my initial idea into a finished piece.

Subjects. All of my inspiration comes from my immediate environment in the two locales where I live and paint—West Chester, Pennsylvania, and Vinalhaven, Maine. I feel very close to my subject matter, which generally consists of three major themes: landscapes or cityscapes, interiors, and flowers.

I often work on several studies of the same subject simultaneously, varying the compositional elements, vantage point, the color and values, and anything else that interests me. When I do a series such as *Farm on Frank Road* (pages 85–91), I constantly compare one painting in the series with another, attempting to keep the good aspects and to change the weaker ones.

The Camera as a Reference Tool. Whereas I used to do all of my work directly from nature, over the years I have increasingly made use of a camera, to take both color slides and black and white prints. With the camera I can record subject matter instantly and from various viewpoints; later on I can study the photographs & perceive ideas that hadn't occurred to me previously. The camera is a handy tool—but only as long as it is used as a *tool*. Slavishly copying photographs in paint produces nothing more than reproductions of photographs. I don't recommend that serious students use photographs in their work for several reasons, the most important of which is not necessarily obvious. A photograph, whether it is a slide or print, has only two dimensions—height and width—whereas the eye perceives nature three-dimensionally. The important dimension of depth can be considerably lacking in a photograph—and to the artist, it is vital to be able to perceive depth in order to convey it in a painting.

Painting from Life. In my outdoor work, I use photography to record facts for later reference. My paintings of interiors and of flowers, on the other hand, are done almost solely from life.

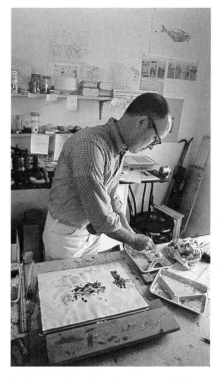

In the studio, I paint vases of flowers from life and also from memory. Increasingly, I paint landscapes indoors as well, using photographs as references when necessary. However, when I paint outdoors on location, the set-up at right is the one I prefer.

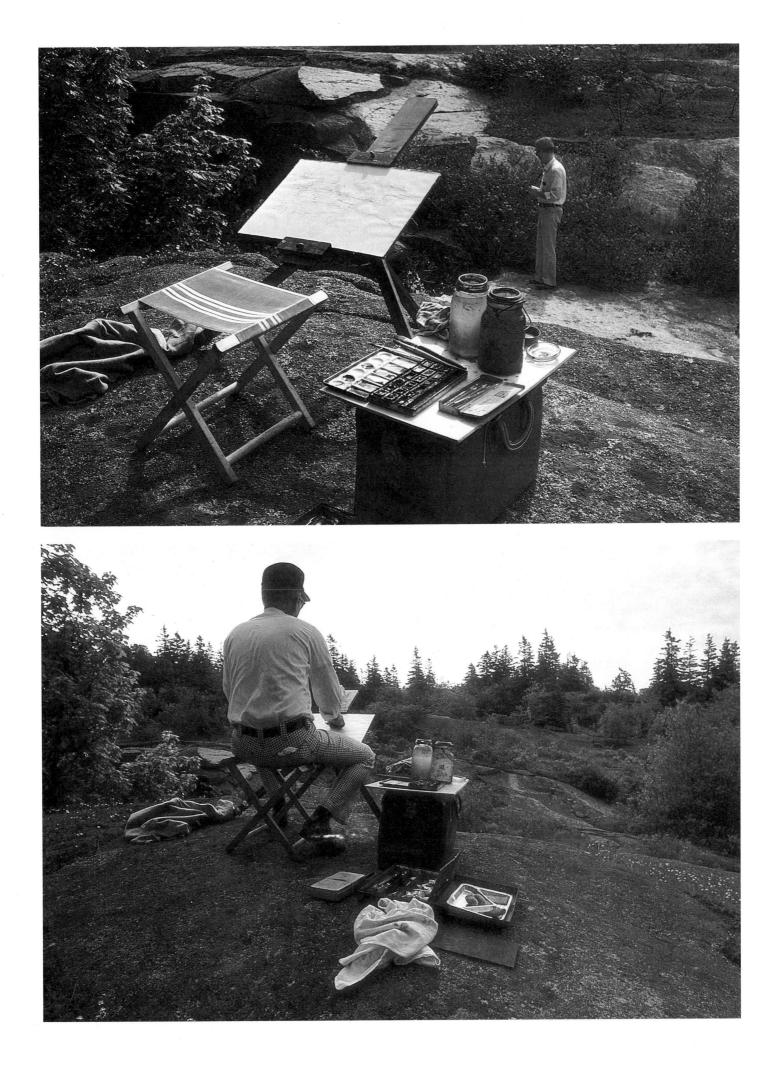

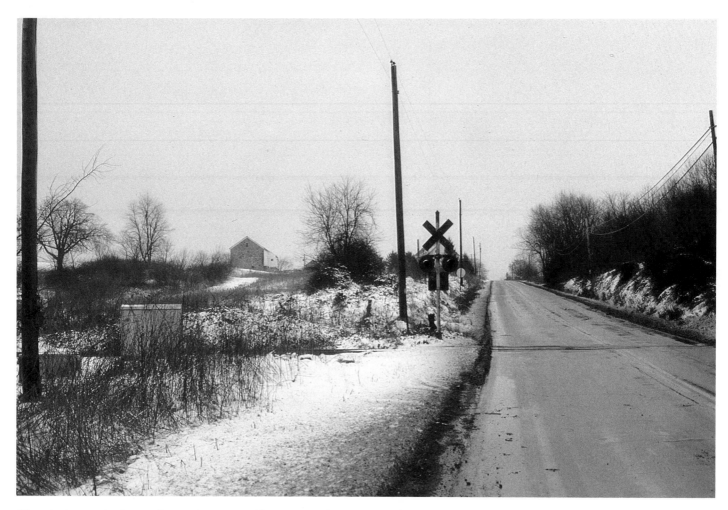

The photograph above shows the actual scene I painted at right. However, if you compare them, you can see that I have strengthened the shape of the snow pattern; and I have simplified and even eliminated certain elements, such as the vertical poles, some trees at left, and the foreground section of the road, to achieve a more pleasing composition.

Above Downingtown (right)
Watercolor
22″ x 21″ (55.9 x 53.3 cm)

This is one of four paintings inspired by a country railroad crossing above Downingtown, Pennsylvania. My eye was captured immediately by the stark, clumsy shape of the metal signal against nature's winter landscape. The play of warm against cool colors was very important in order to portray the feeling of light that I desired. Because of this, and especially because I was using a smooth watercolor paper, I had great difficulty with the large, plain sky. It was painted in and washed out several times before I was satisfied with the result.

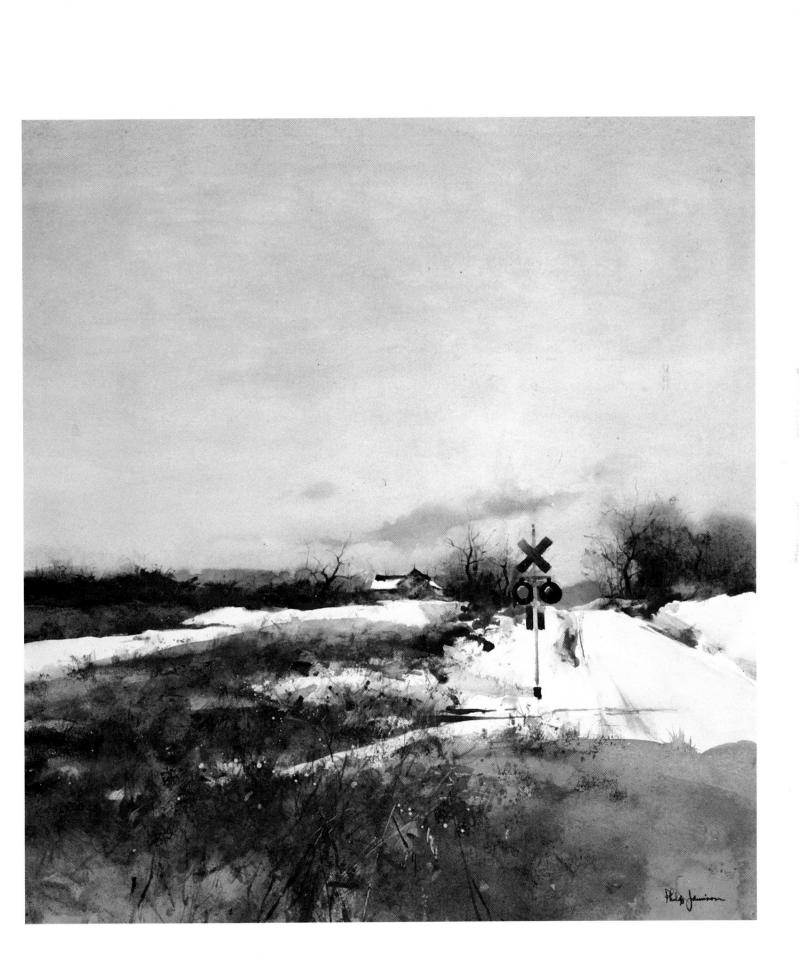

This is due to the fact that I have greater control over both the composition and the light when painting indoors and can eliminate some of the problems that arise in outdoor landscape painting. While I am in Maine, my studio is usually overflowing with continuously changing vases of freshly picked summer wildflowers. But even when I paint directly from the subject, my thinking and painting processes remain essentially the same as for landscapes: I am endlessly changing and revising as I paint. I am never certain what will and will not work.

"Overworking." During the process of painting, most of my watercolors—whether they are individual paintings or part of a series—change considerably from start to finish. I constantly scrub out and repaint areas, often reworking an entire section several times. For this reason, it is important to me to use a good strong rag paper that will take the punishment. I do not believe in the old adage that a watercolor must not be *worked over*. It simply should not *look overworked*.

"Style." I seldom use the word *style* and have a strong dislike for it—it seems superficial, as does *technique*. I have never been an advocate of using many gimmicks or painting tricks. If you look at an artist's finished work and immediately are struck by its technique, or wonder how it was done, there is probably something wrong with that painting. If "technique" is all that a painting says, it doesn't say anything. Undoubtedly all great painters have good technique, but *how* they say something isn't nearly as important as *what* they say. Watercolorists such as John Marin, Charles Demuth, and Dong Kingman, who have a very distinctive way of applying the paint to the paper, are sometimes misunderstood by the average person. These artists did not dream up tricky techniques overnight simply to catch the eye; rather, their individual ways of painting developed gradually over a long period of time. Their so-called styles grew naturally, as they grew. The development of a serious artist is a slow, gradual process, and technique should be of little or no consideration. It is something that just happens. However, if you study the work of the museum-worthy painters, you will notice that the spark of genius so obvious in their mature work is usually present or hinted at in their very early attempts.

A collection of treasured mementos and original paintings graces my studio wall. Clockwise from top right: a Hobson Pittman watercolor, a pastel by Arthur B. Carles, pencil sketches drawn by my grandfather, a watercolor by my wife, Jane, a pencil sketch by Linda Jamison (one of my twin daughters) at age four, a Paul Wescott oil painting, and in the center, a small Andrew Wyeth watercolor.

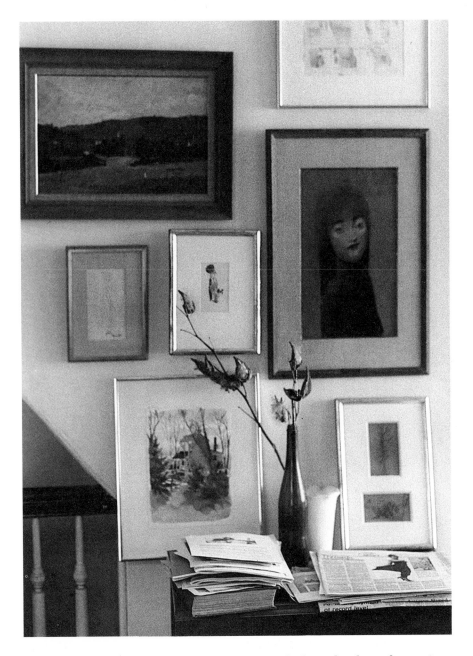

Inspiration. Usually my head is crowded with ideas for paintings, although certainly I don't always feel like painting. I find painting very exciting, but it can also be exhausting. There are times when I just have to stop and think, and other times when I must relax by getting completely away from it. However, I structure my working time and I usually do try to paint whether I feel in the mood or not.

To me, the process of painting is the important thing. An exciting inspiration may not lead to anything but a dull painting;

on the other hand, even if I am not feeling particularly inspired, just by starting to paint I can often build up to something quite exciting. As soon as I get involved, the ideas seem to develop automatically, one thing constantly leading to another. The age-old notion that the artist must sit around waiting for a world-shaking inspiration to hit him is just so much hooey as far as I am concerned.

THE PAINTING PROCESS

The Drawing. Although I do very little in the way of preparatory sketches for my paintings, I often do a thumbnail sketch either in pencil or watercolor, primarily to establish the light-and-dark patterns. Strangely, when I do decide to do a small watercolor study as part of my thought process, I usually become so involved with it that eventually it becomes a "finished" painting!

I begin a watercolor by drawing in the large shapes with a soft 3B pencil. I make it a point to draw no more than is absolutely necessary, since I find that the more detailed my drawing is, the more restricted and inhibited I shall be when it comes time to paint. My own rule is "Don't draw it if you can paint it with a brush." Of course, in many cases, I find a more detailed drawing essential, especially where perspective and figures are involved.

Establishing the Major Values. My usual approach is to paint from light to dark, quickly covering as much of the paper as possible so I can properly relate one color and value to another and not be confused by the glaring white of the paper. There is only one exception to this: At an early stage I like to put in at least a sampling of my darkest value so that I can constantly relate the lighter values to it as I paint. In the first stages of the painting I deal with the large areas and attempt to keep the painting as free and loose as possible. This enables me to make changes and, in a sense, "push the painting around" in much the same way as a sculptor works with clay.

Building the Composition. Starting out with the larger, simple shapes I try to build up a strong pattern on the paper, always using the largest brush possible to accomplish any given task. I often place cut-out pieces of paper (for example, white paper

A natural sponge is handy for both scrubbing out areas and applying paint to create texture.

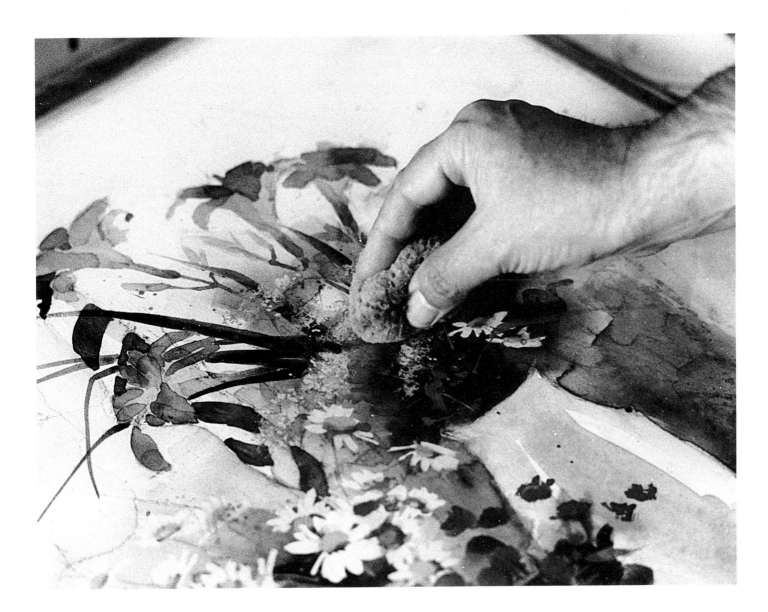

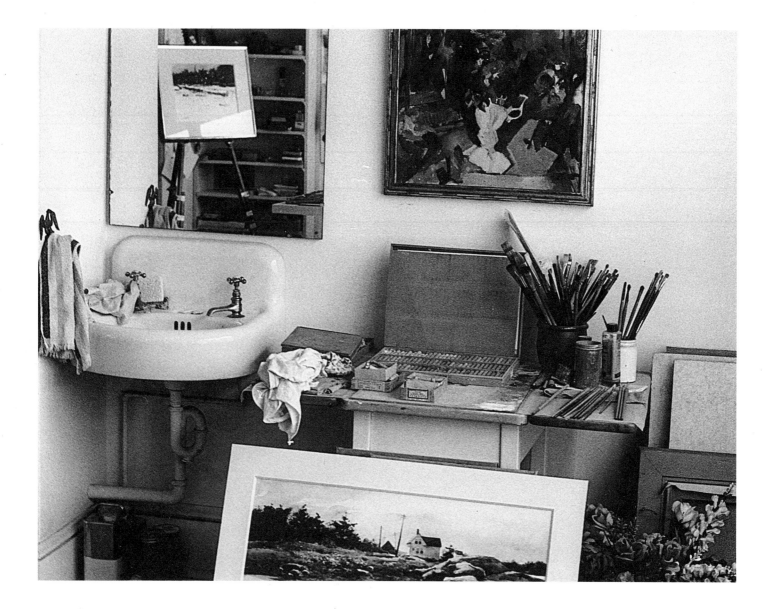

The clean-up area also harbors a stand for my oil-painting equipment, pastels, and most importantly, a mirror for studying paintings-in-progress in a working mat.

for snow shapes) on my watercolor to help me visualize how a change would look before I actually make the change. This frequently saves time and costly mistakes.

It is not until I am somewhat satisfied with the overall pattern that I even think about getting involved with detail. Once I have established all of the big values correctly, I can "hang" any amount of detail on the composition and the detail will hold its place: but if the large values are wrong, no amount of detail is going to help it.

Light. Light is becoming increasingly important to me. This does not necessarily mean a direct source of light, but rather diffused light within space—just a feeling of light existing in a painting. I seldom use strong sunlight or even strong artificial light in a painting, as this dictates the pattern of the shapes. This is why, for years, I did most of my landscapes on cloudy days. I was able to form my own shapes with the land masses and colors rather than have the sun determine the light-and-dark pattern. This freedom became especially important to me while doing winter landscapes with snow. I could move the snowy patches around like pieces of a jigsaw puzzle until I found the arrangement I liked best.

Watercolor Techniques. Since I believe that "technique" should be subordinate to *what* I am saying in my painting, I use whatever painting methods will suit my purpose at the moment—washes, wet-in-wet, painting directly, drybrushing, and so on. While I don't use an overall wet-in-wet technique, I do paint wet-in-wet in many areas that call for it, such as skies and grass areas where I want the paint to flow together or bleed into soft edges.

Using a Working Mat. While I paint, I constantly take time out to contemplate what I am going to do next. Each brushstroke that I put down on the paper may change my idea of how I want to proceed. This accounts, in part, for why my original idea and the finished painting may be quite different. I often put my paintings in a white "working mat" and place them on an easel next to my painting table. By viewing them in reverse as they reflect in a large plate-glass mirror on the opposite side of the studio, I am able to observe them from a somewhat new viewpoint. The white mat isolates the picture from any con-

fusing interference from its surroundings, including the ragged paint edges of the watercolor itself.

Contemplating the Results. Often I become so involved in the painting process itself that certain elements in my painting get overlooked. When I have carried a watercolor as far as I can for the time being, I prefer to put it away, for a period of weeks if possible, so that when I return to it I can judge it with a fresh eye. In this manner I can perceive its more obvious shortcomings at a glance.

Drying. I use several methods for drying my watercolors. Of course, the sun takes care of this when I am painting outside during the warm months. When doing studio work, I often take time out to put the painting outside, and the sun and breeze dry it quite rapidly. However, during the cold, sunless winter days I sometimes can't wait for the paint to dry naturally. In this case, a hand-held hair dryer can be effective, but usually I prefer to hold the painting upside down over either a hot-air duct in my studio or over a gas or electric stove. Naturally, any large puddles of water must be removed before I turn the painting over, in order to prevent running.

AFTER THE PAINTING IS FINISHED
Once a painting is completed, a very important step still remains—that of matting and framing it. The presentation of a painting can either enhance or detract from the artwork, depending on how it is done.

Matting. Most museums and watercolorists, including myself, generally use a white or off-white mat next to the painting, and a frame of narrower width. The mat serves two purposes: one is to set off the painting from its surroundings, and the other is to isolate it from the glass so that it will have sufficient "breathing space."

I always try, if possible, to have the watercolor paper touching nothing but all-rag, acid-free mat board—this goes for both the mat and the backing material. This minimizes the chance of impurities getting to the paper and discoloring it. Unfortunately, a good watercolor paper is no better than the materials with which it comes into contact. This is why, in museums, most watercolors are matted with off-white, 100-percent rag,

acid-free mat board instead of the fancy trappings you often see on paintings elsewhere, which probably contain many impurities.

Framing. The framing of paintings is a personal choice, and there is always more than one "correct" way. And, like fashions in clothes, frame styles change with the times; a visit to any large museum will show you how certain styles of frames were fashionable during various periods in art history.

In most cases, I prefer to use as narrow a frame as possible, but one that can still bear the weight of the glass. Usually I like it to be neutral in color, for the painting is the primary object. The frame should support the painting and blend in with it, but be of secondary importance.

Conservation. I believe very strongly in conservation as it relates to works of art on paper. It is a comparatively new and expanding professional field, and one that is understood by far too few—artists, framers, and laymen alike. It is something that usually isn't visible to the average eye—and unfortunately, it also carries a higher price tag to the artist purchasing matting and framing materials, the art patron, museums on tight budgets, and also small galleries which may need to keep their costs down to make a profit. Nevertheless, it is good to note that as time goes by, conservation is becoming more and more common knowledge to all concerned. Hopefully this will enable more of today's art treasures to be preserved, and for a longer period of time, than were their counterparts in the past.

PART TWO

DEMONSTRATIONS

Anthony's Fish House

Watercolor, 10½" x 14½" (26.7 x 36.8 cm)

Step 1. For this painting of a typical Maine fish house, the lobsterman's home base, I choose a 140-pound cold-pressed RWS paper. I want to portray the warmth of a summer day and its lush greens, so I begin my painting by laying-in a warm wash of raw sienna mixed with lemon yellow over the sky area; then I cover the foreground grass areas with a wash of raw sienna, yellow ochre, and olive green. Done with a 1-inch flat brush, both washes are just underlays; later I will apply heavier colors over them. When the sky area is dry, I wet it again with my 1-inch brush and float in a second wash, composed of Davy's gray, cobalt, and cerulean blue, to cool the warm undercoat. With a No. 8 sable, I brush in an almost flat strip of raw sienna to represent the distant field.

Step 2. Using a 1-inch flat wash brush and a No. 8 sable brush, I begin to work over the entire foreground of the painting for the second time in order to intensify and deepen it in both color and value. The lower half of the marshy grasses is worked wet-in-wet, using olive green and viridian interworked with tones of raw sienna, raw umber, and yellow ochre. I apply a tint of Payne's gray to the area on the right side and then brush in a few direct strokes to indicate some rocks. Next, using a No. 12 sable brush, I put in the distant strip of pine trees to establish my darkest value. The closer pines are painted with a combination of olive green and Payne's gray. I paint the most distant tree line in a lighter, cooler value of cerulean blue in order to make it recede. This completes what I consider the most important stage in developing the watercolor: covering most of the paper and establishing a feeling of light and depth.

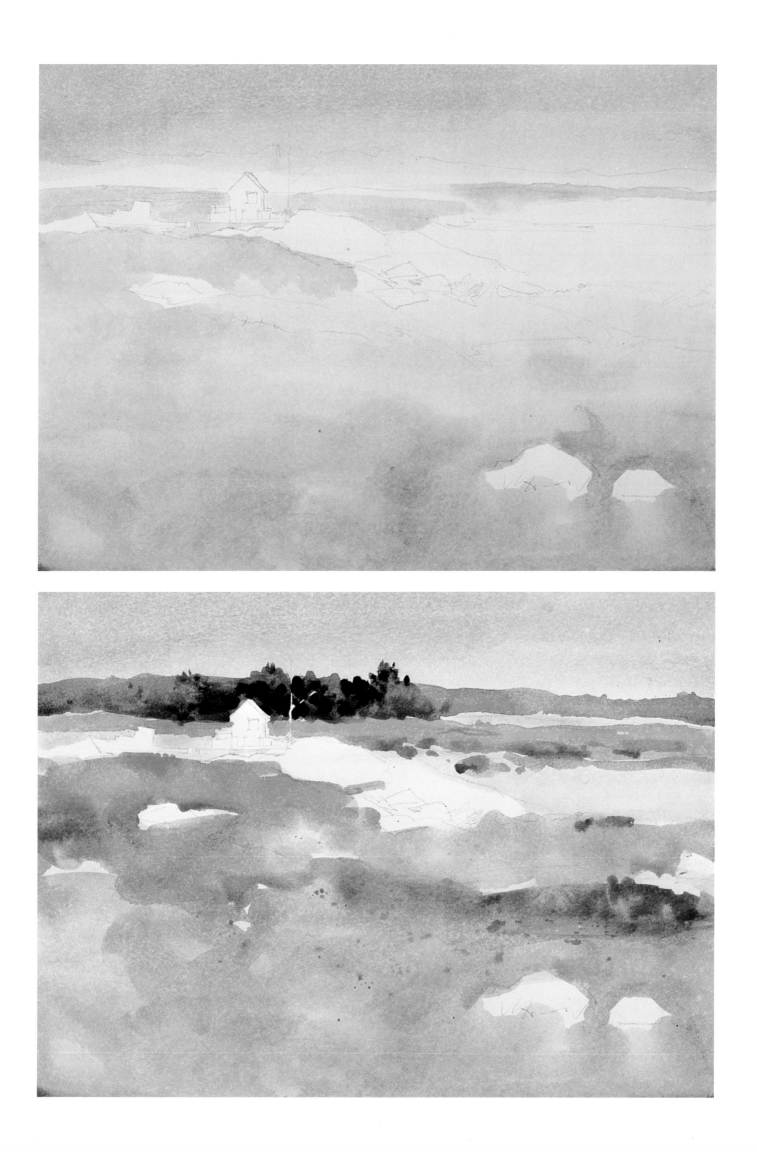

Step 3. I concentrate now on eliminating some of the white space that is left, by placing a yellow ochre wash on the rocks to give them the warm cast of sunlight. When this is dry, I brush in details of the individual rocks along the high-tide line, using a blend of Payne's gray, Vandyke brown, and alizarin crimson. For a third time, I go over most of the foreground with transparent layers of olive green and viridian, and the warm earth hues—yellow ochre, raw sienna, and raw umber: I want to enrich the values and colors while allowing the underlying work to shine through. For the larger areas I use a 1-inch wash brush, and for the more detailed work, I employ my No. 8 and No. 12 red sables.

Step 4. With a combination of Payne's gray and olive green, I paint the fish house. For the detailed work in the "busy" section of the painting, I use a pointed No. 4 sable brush, being careful not to cover the wharf and the crates that rest upon it. With a No. 8 sable, I paint the high-tide line very directly, using a warm Payne's gray to make the boat come forward.

I darken the foreground and attempt to add form and a sense of movement to the grassy shapes. A few scratches with a penknife indicate individual grasses. As I work, I am constantly relating each part of the painting to every other part, adding other minor touches here and there.

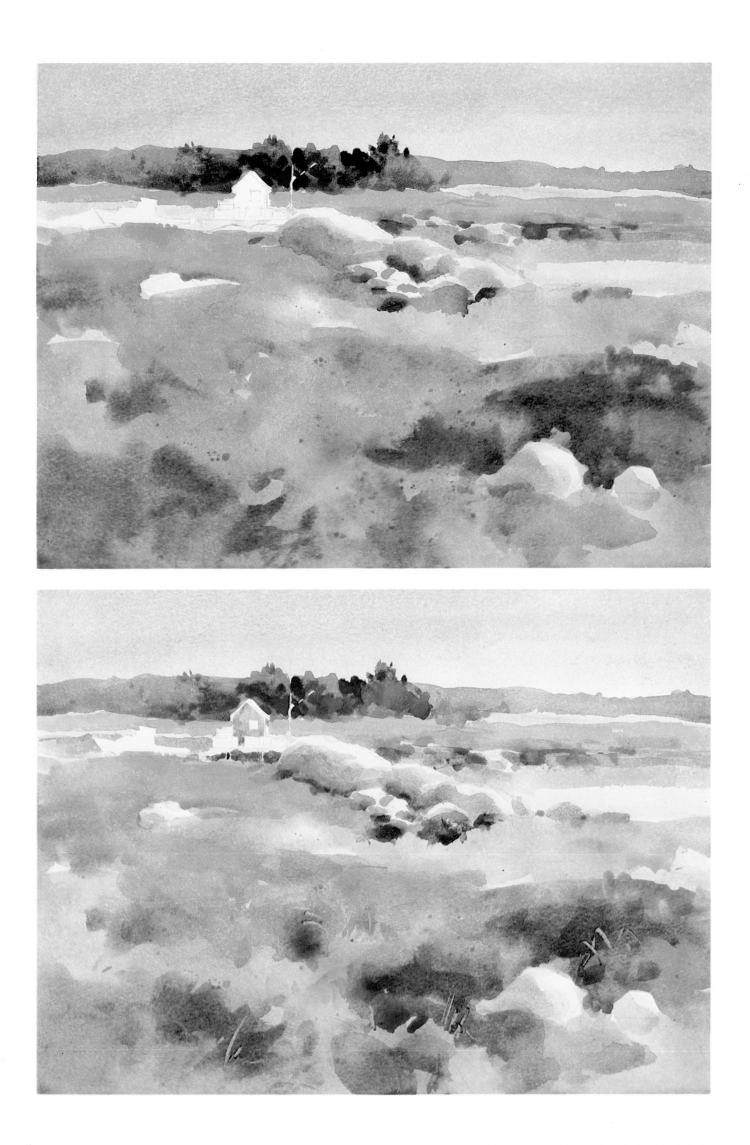

Step 5. I continue to explore the foreground and drop in smaller washes of greens and browns. Using a cosmetic sponge, I lighten the tops of several rocks; then I take a No. 8 sable brush and add the darker rocks running off the right center of the watercolor. I complete the details around the fish house, taking care to keep them simple. Then I try to add more interest to the grasses.

Over all of the previously painted layers of transparent washes, I suggest clusters of individual flowers and grasses with semiopaque and opaque colors. The grasses are chiefly a mixture of permanent white, viridian, and cadmium yellow pale. The flowers consist of cadmium yellow and cadmium yellow pale mixed with permanent white. I am careful to limit the size of these opaquely painted sections so that they will form an integral part of the transparent watercolor and won't "jump out" or become heavy-looking. To indicate these details, I employ a sponge dipped in paint as well as my fingers and No. 4 and No. 8 sable brushes.

When a section appears overworked, I wipe it out with a wet sponge and rework it. By working back and forth in this manner, I find I can more readily obtain a feeling of a *field* of grass as opposed to painting the many blades of grasses individually. I complete the watercolor by indicating a few gulls in opaque white.

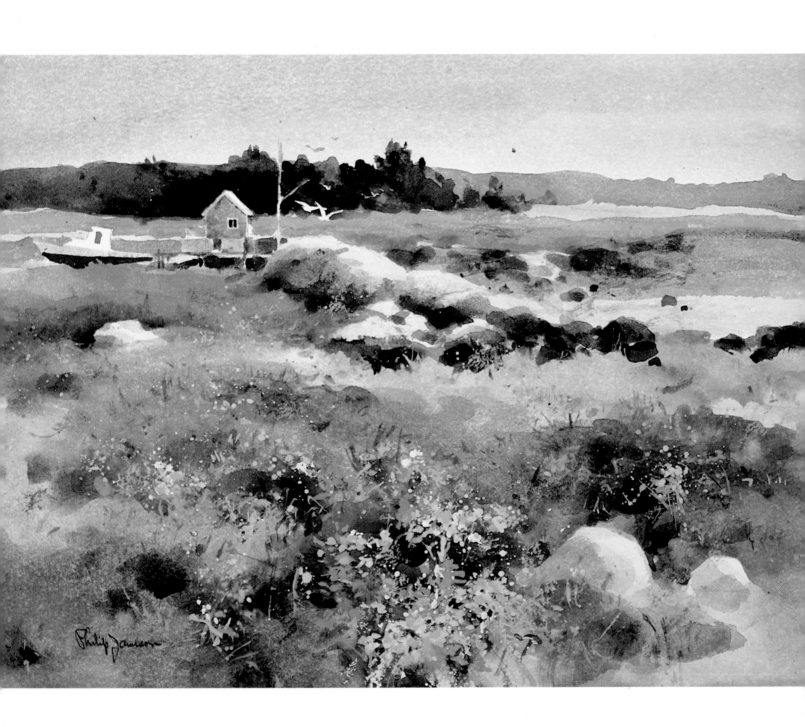

Abernethy's Farm

Watercolor, 10" x 14⅝" (25.4 x 37 cm)

Step 1. Abstract design and color are of equal interest to me as I start this watercolor of a local farm on a cold-pressed 140-pound paper. I take special care in drawing the house as I lightly sketch in the scene with a pencil; I want the shapes of the various snow-covered roofs to be the focal point of the painting. In a sense the composition is almost divided in half, with cool colors at the top and warm colors in the lower half. The placement of the colors also assists in creating a feeling of depth—the cools recede, and the warm colors come forward.

Initially I cover the sky area with a warm underlay wash of yellow ochre. When this is dry, I paint a second, cooler wash of Davy's gray over the warm sky wash. From there I work right down the painting from top to bottom, almost without stopping, leaving the white of the paper for snow patches. Most large areas of paint are isolated from each other so they won't run together; however, within each individual area I allow the colors to flow into each other freely. The distant hills are primarily Prussian blue and Payne's gray. The one spot of red denoting the tin roof is a mixture of alizarin crimson and Payne's gray. The foreground grasses are a mixture of most of the warm earth colors in my palette; the texture of the grasses is painted rapidly with a No. 4 sable brush.

This first step in painting the picture is unusually complete for my method of working. It goes very quickly, and details just seem to fall into place.

Step 2. A logical progression seems to develop easily through this step in my painting, which is certainly not always the case. I darken sections of the house and some middle-distance trees with Davy's gray and Vandyke brown. In the tree line I dampen the area first with a 1-inch flat brush, drop in the paint, and allow it to spread out, forming soft edges. I do the same with the tree and brush forms at left center. Using a wet-in-wet technique, I develop the large grass shape in the foreground with earth colors—yellow ochre, raw umber, raw sienna, burnt sienna, and Vandyke brown. After this underlying wash is dry, I casually drybrush over the area with the same colors to create texture. Then I paint the trees, the darkest note in the painting, quite directly with Payne's gray and Vandyke brown, taking care to keep the limb forms smaller and lighter in value as they stretch out from the heavier trunks.

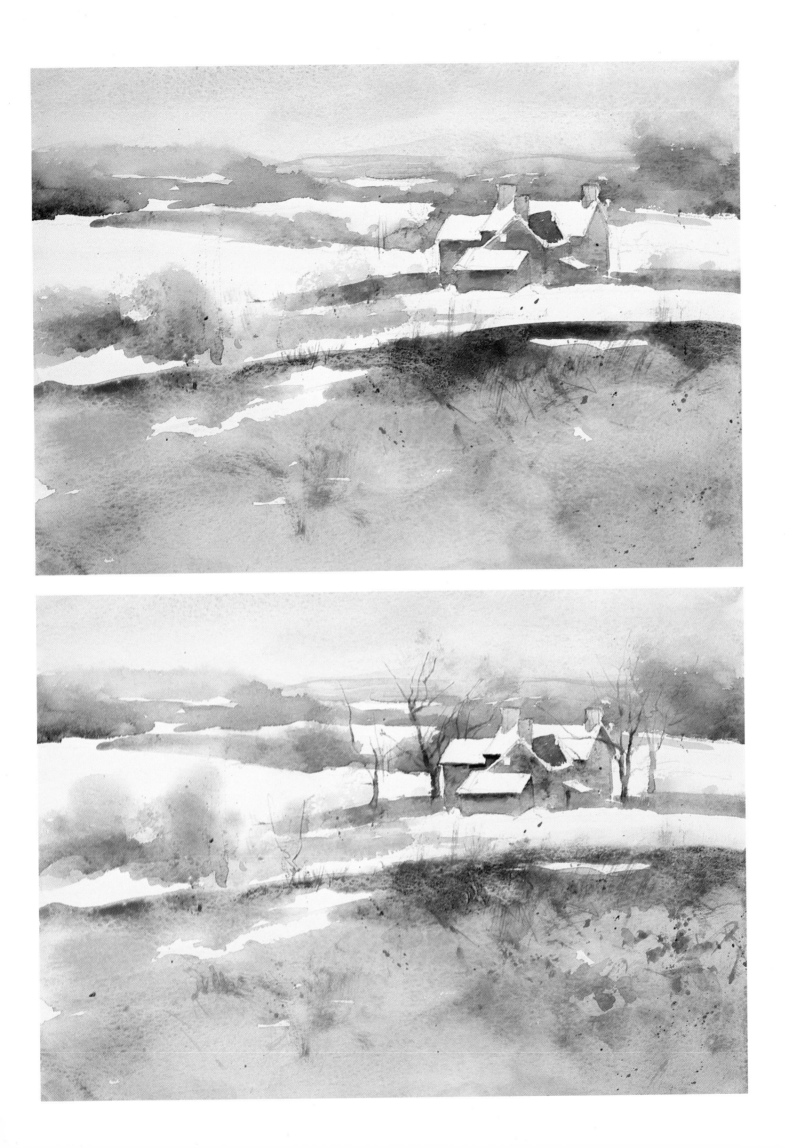

Step 3. This step is a simple continuation of Step 2. I add the smaller trees at left and again work over the foreground, using the same method as before. I make minute changes in the house, where I am especially concerned about bringing out the form of the building and the chimneys. Although the house is quite small in relation to the rest of the painting, it presents some fairly complicated perspective problems. I want it to be correctly drawn, but at the same time the actual painting of it must be as simple as possible. I try to improve the shape of the horizontal strip of snow at right center by rubbing out a small section with a damp cosmetic sponge.

Step 4. At this point I find it necessary to put the painting aside for a few days so I can look at it with a fresh eye. When I come back to it, I enrich the foreground for the fourth time with subtle washes of olive green, burnt sienna, raw umber, and raw sienna. I add details to the left foreground trees as well as the windows of the house. Now that the watercolor is almost complete, my main concern is the abstract pattern of the light and dark shapes. I'm not pleased with the shape of the horizontal strip of snow at right center, so I cut some white paper into strips of various shapes and move them around the painting until I arrive at a satisfying pattern. Then I scrub this area out of the foreground grasses until I am down to the white of the paper. Finally, to strengthen the design, I lay-in a darker, soft-edged wash over the middle-distance trees and the line of small shrubs at left center.

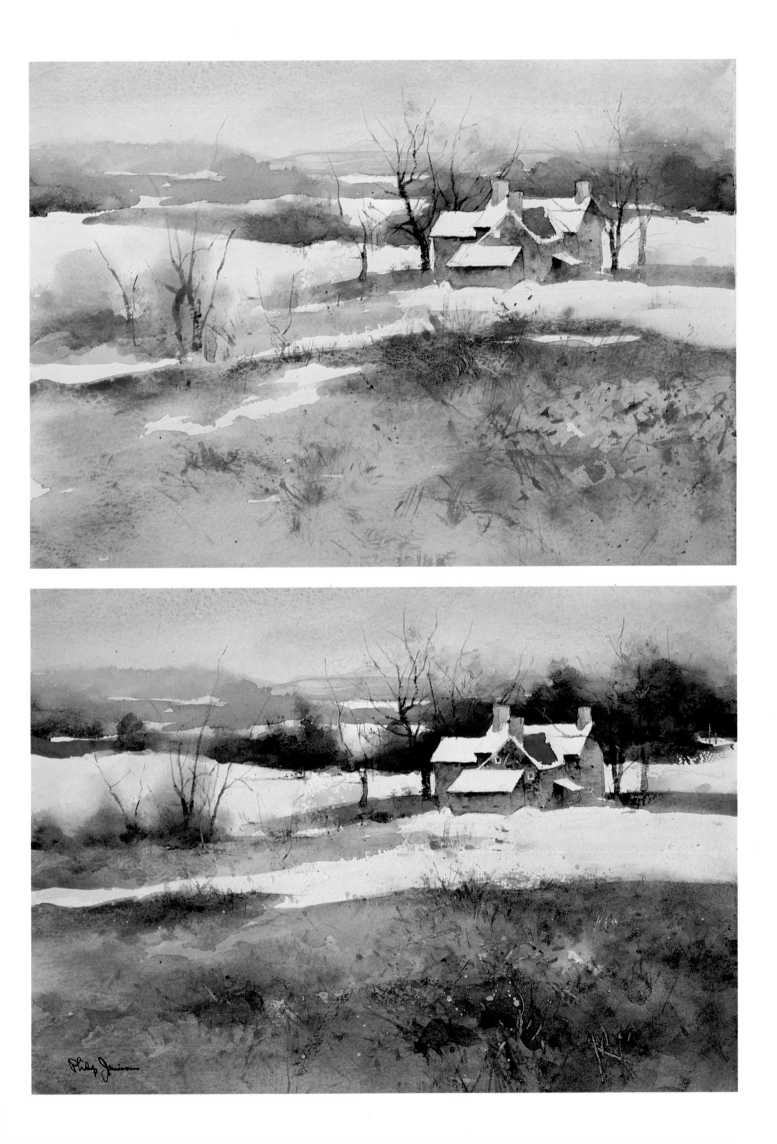

Sunset Hollow

Watercolor, 10¾″ x 15½″ (27.3 x 39.4 cm)

Step 1. A two-hundred-year-old farmhouse, nestled in a valley near my home, attracted my interest the first time I saw it many years ago. Since then I have done several paintings of it at various times of the year. In the winter, its red-painted tin roof stands out against the white blanket of snow that covers the hillside.

For this watercolor I choose a two-ply, 100-percent rag drawing paper with a medium-smooth surface, and stretch it on a board while damp. I want to paint this solitary house from a distance in order to show the environment in which it exists. My major concern is the division of the three main spaces in the composition: the sky, the very simple white foreground, and the center section, which contains practically all of the interest. After determining these shapes, I draw in the basic forms with a pencil. Leaving the white of the paper for snow, I quickly paint the larger light areas. Using a 1-inch flat brush, I flow a continuous wash over the sky, starting with a warm yellow ochre tint at the horizon and blending into a cooler mixture of Davy's gray and cobalt blue toward the top. I apply other light washes of Davy's gray to the shadow areas of the snow, the house, and the trees adjacent to it.

Step 2. Now I indicate distant grasses adjacent to the sky area with various combinations of yellow ochre, raw umber, olive green, and burnt sienna. Each of the three sections of this grassy area is slightly different in color, in order to give the landscape a feeling of variety and color. My next concern is to establish my darkest value—the cluster of pine trees to the right of the house. Once this is done, it will be much easier to obtain the correct value relationships of succeeding washes by comparing them to this dark value. The pines are painted basically with olive green and ivory black, using my No. 12 sable brush. I am careful to keep the black from deadening the green, as too much black can easily kill the color of a painting. I apply a hint of a wash to the house as I start to consider its form.

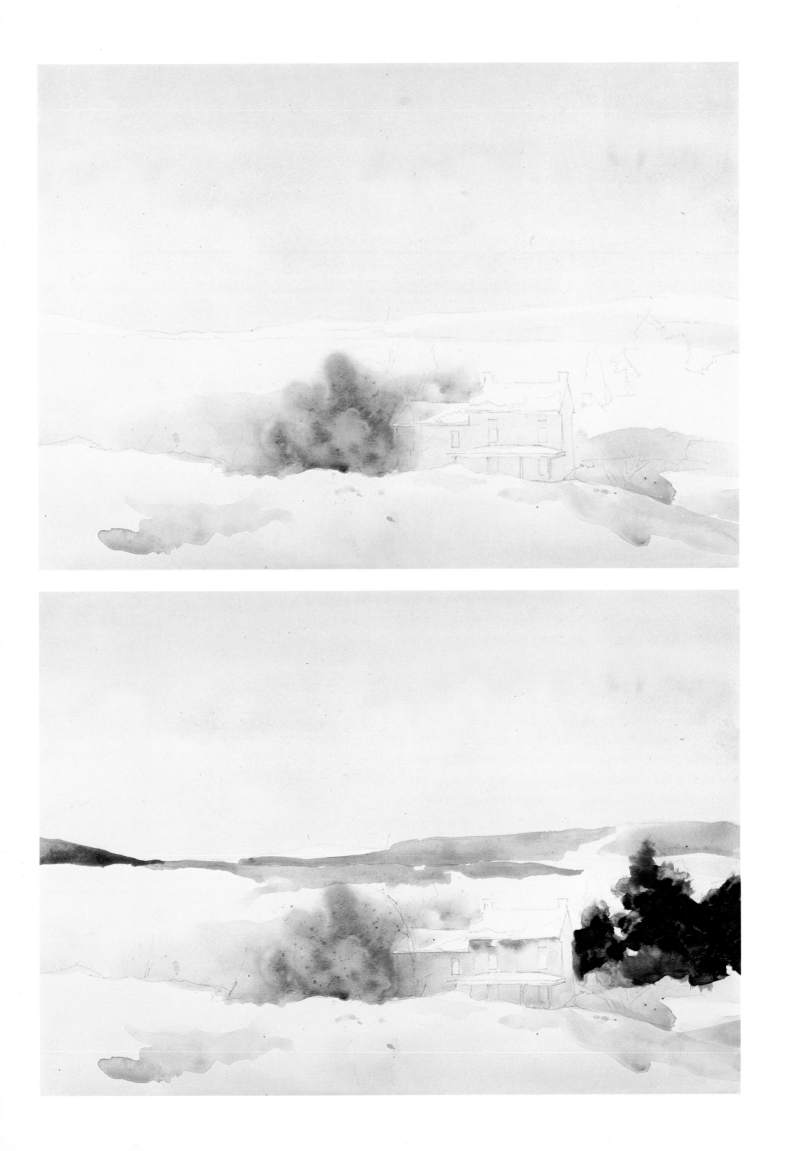

Step 3. Still working to establish the main values of the scene, I next put in a mixture of Indian red, alizarin, and Payne's gray for the strong red of the tin roof; then I paint the other roof with Payne's gray. I am very careful to leave distinct patterns of snow on each roof. These patterns will eventually become an important element of the design. To further define the form of the stuccoed house, I brush a cool wash of Davy's gray onto the right side and under the porch. After dampening a small area of the paper with a 1-inch flat wash brush, I drop in some Davy's gray to suggest the trees on the distant hills. The tree area to the left of the house is handled in the same way with Vandyke brown, to give it a bushlike quality. Against the dark pines I indicate another tree, painting the trunk with a brush and then scratching out a few suggestions of branches with a penknife.

Step 4. With tones of Davy's gray, Payne's gray, and Vandyke brown, I paint the central tree in front of the house. This tree increases the feeling of depth in the watercolor and also adds a stark, linear quality which contrasts with the rest of the painting. Texture plays an important role in my work, and in most cases I build it up in layers—some layers are painted wet-in-wet, some drybrushed, and still others are a combination of the two. I combine the two methods to further develop the distant hills and the trees to the left of the house. As the painting progresses, I am continually working over the entire paper; I seldom finish one area before proceeding to another. I add more form to the house by putting dark, warm tones of raw umber and raw sienna under the eave.

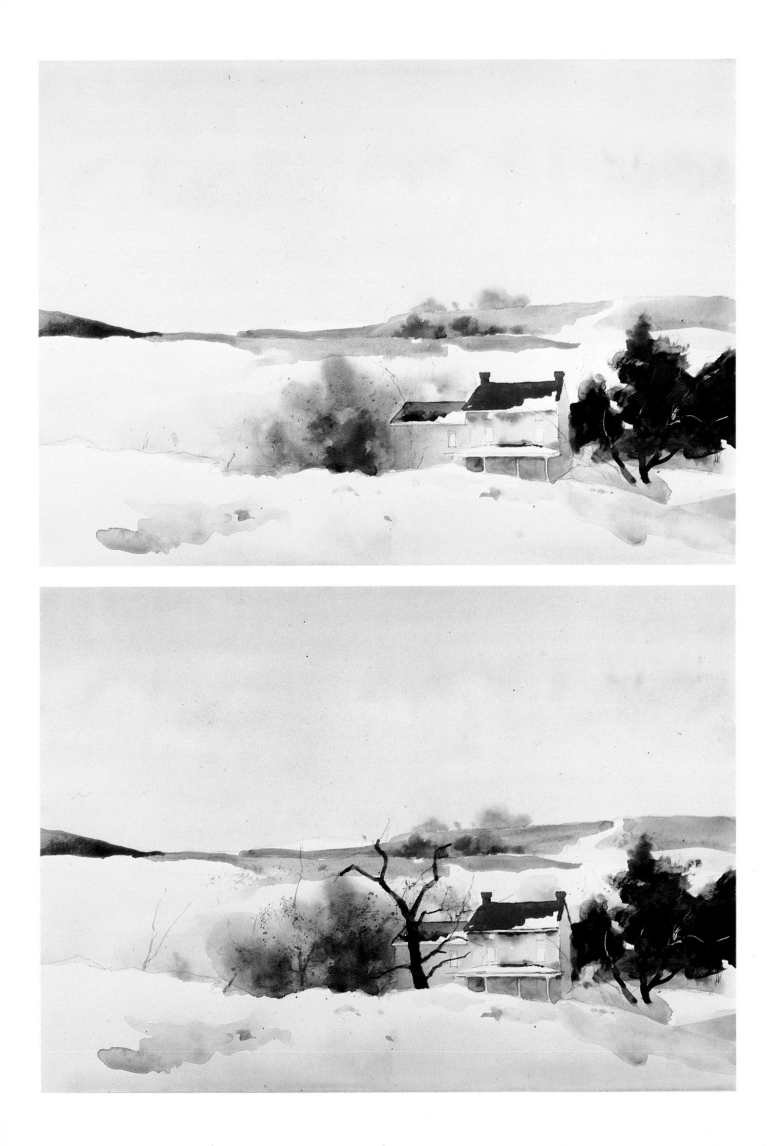

Step 5. By this stage of the painting, all the main elements have been established and it is now simply a question of refinement. I want to keep the sky area, which encompasses more than half the painting, very simple in concept, but I don't want it to be overly empty. I decide to add a single cloud formation by wetting the area and dropping in a subtle blend of Davy's gray and cerulean blue. It appears simple when I have finished it, but I have given the shape and placement of this cloud more thought than any other single element in the painting. Without it, I feel the largest area of the watercolor would lack interest. I add small washes of Davy's gray to indicate the windows; and, by adding thin layers of paint and creating texture, I further strengthen the rest of the central section of the painting.

Step 6. During the final stage of this watercolor, as with most of my paintings, I spend more and more time planning than actually painting. After bringing the windows to what I feel is a "finished" state, I make many smaller refinements throughout the central section of the picture by adding various washes and textures. I also effect certain subtle changes by removing some areas with a wet sponge—a portion of the cool shadow in the left foreground, for example, and a small section of the dark pine trees. After careful consideration, I add a spatter of opaque white to indicate falling snow. This is the only opaque watercolor I have used in the entire painting.

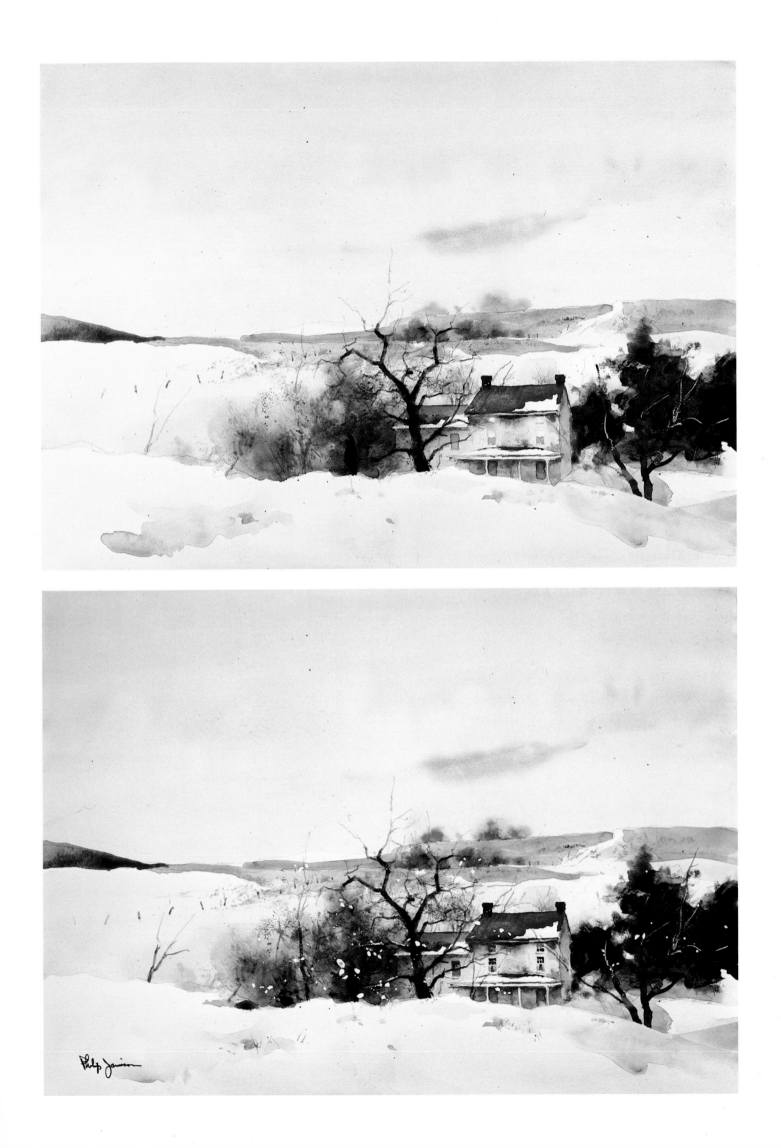

Buttonwood

Watercolor, 7½" x 11⅜" (19.1 x 28.9 cm)

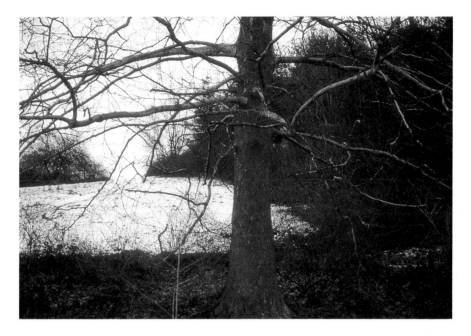

This photograph will be a useful reference in painting the buttonwood tree, as long as I don't try to copy it literally. Ultimately, I must alter, eliminate, or emphasize elements of the scene according to the needs of the painting.

Step 1. The subject of this small watercolor is a stately buttonwood tree that I have painted on several previous occasions. I select a sheet of 72-pound, 100-percent linen cold-pressed watercolor paper and begin by drawing in only the essential lines with a soft pencil. Working from top to bottom, I lay-in a light wash of Davy's gray, applying it with a 1-inch wash brush, for what is to become the sky area. When this is dry, I brush on a horizontal strip, using a mixture of raw sienna, Vandyke brown, and burnt sienna, to represent some middleground grasses. Using the same colors, I also flow on the barest warm underlay for the trunk of the buttonwood.

Step 2. In this painting I want to stress the large, simple light-and-dark pattern, and I am anxious to establish this pattern on the paper quickly. Therefore, my next step is to paint in the substantial dark shape of the background pine trees, being careful to paint around a few of the lighter buttonwood limbs. The color I use for this area is a mixture of olive green, Vandyke brown, and ivory black. I use Davy's gray and Payne's gray for the strip going off to the left, to suggest a receding tree line. Two foreground shapes on either side of the tree are loosely painted with olive green and Davy's gray. Once these dark areas have been established, the sky seems too light in value, so I mix another wash of Davy's gray and carefully flow a second layer over the original sky.

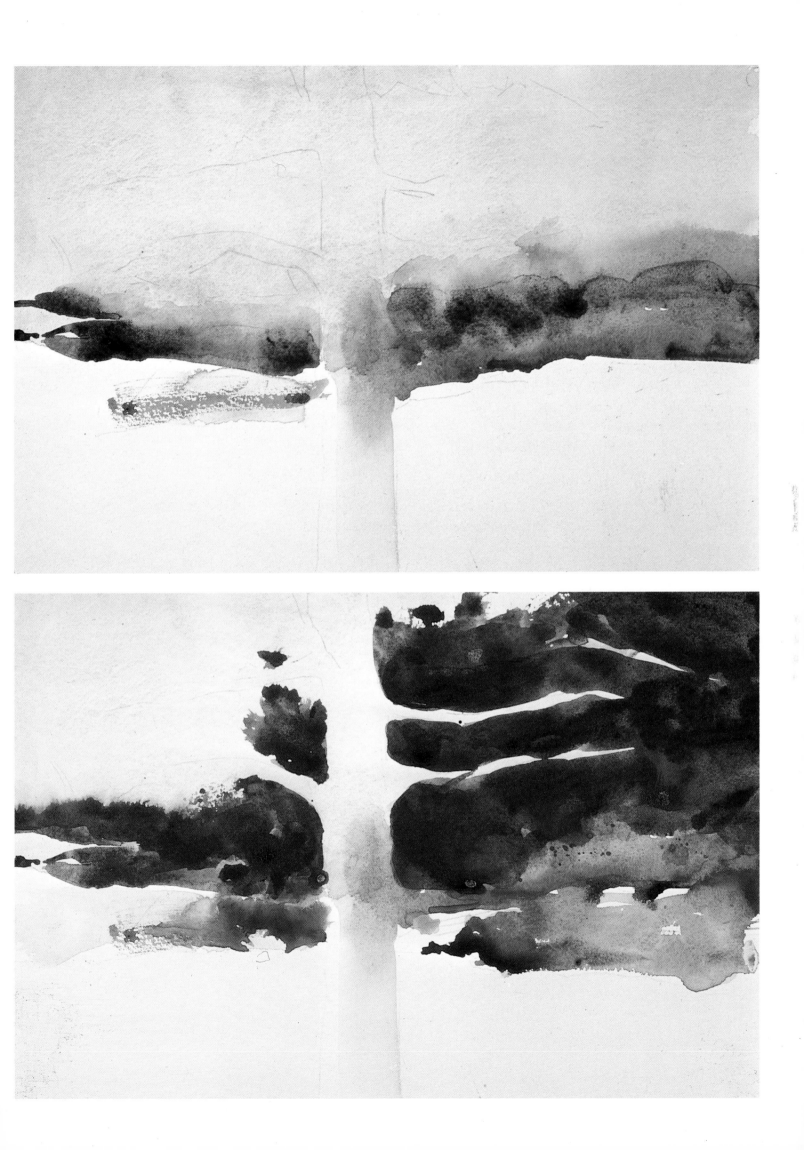

Step 3. To lay-in the overall light-and-dark pattern on the paper, I now use Davy's gray, olive green, and yellow ochre to indicate the tree trunk and a few limbs. Now that all the basic parts of the watercolor are complete, I can study the painting and decide what I need to do to improve and finish it. Using olive green, Vandyke brown, ivory black, Davy's gray, and Payne's gray, I put in some smaller washes here and there, and further darken the middleground and the backdrop of pine trees. To give the buttonwood its characteristic texture, I use my No. 8 sable to drybrush some Vandyke brown onto the trunk. Wetting the upper right-hand corner of the paper, I use a single-edge razor blade to scrape out the tree limbs where they overlap the pine trees in the background.

Step 4. To add more form and dimension, I develop the tree, adding more limbs with a No. 4 sable brush and scraping some out with a razor blade. As I paint, I am constantly attempting to acquire a "lost and found" quality so that the overall feeling isn't obliterated in a sea of detail. I want the viewer to see a buttonwood tree, but not to start counting the limbs. When I first visualized this painting in my mind, I knew that I wanted the buttonwood to be almost dead center on the paper. Dividing the paper into two equal parts doesn't usually lead to a very interesting composition. However, in this instance, the *shape* of the dark mass of pines blends into the tree shape, thereby not only disguising the equal division, but also creating a new and more exciting composition.

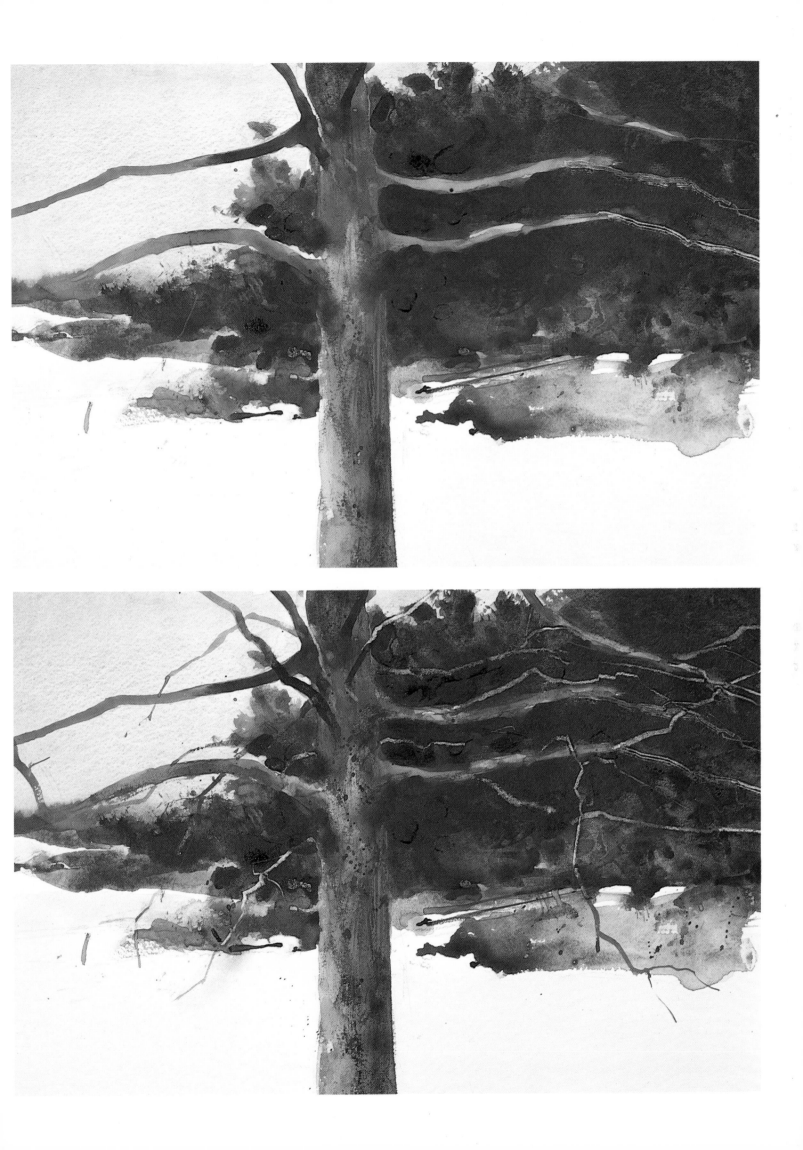

Step 5. At this point I begin to spend less time actually painting than planning the finishing touches. Using olive green and ivory black, I freely but carefully define some outside edges of the pine trees. This large mass of pines is almost totally black. Only their silhouette against the light sky portrays their character, and that is why I devote so much attention to it. I fill in the unwanted white space at far right and make other minor adjustments, including allowing a little raw sienna to run into the gray shape in the right foreground. I add some barely discernible textures here and there with drybrush.

The most noticeable addition to the painting—and the most important—is the snow flurries, which I add by flicking permanent white paint from my No. 4 sable brush.

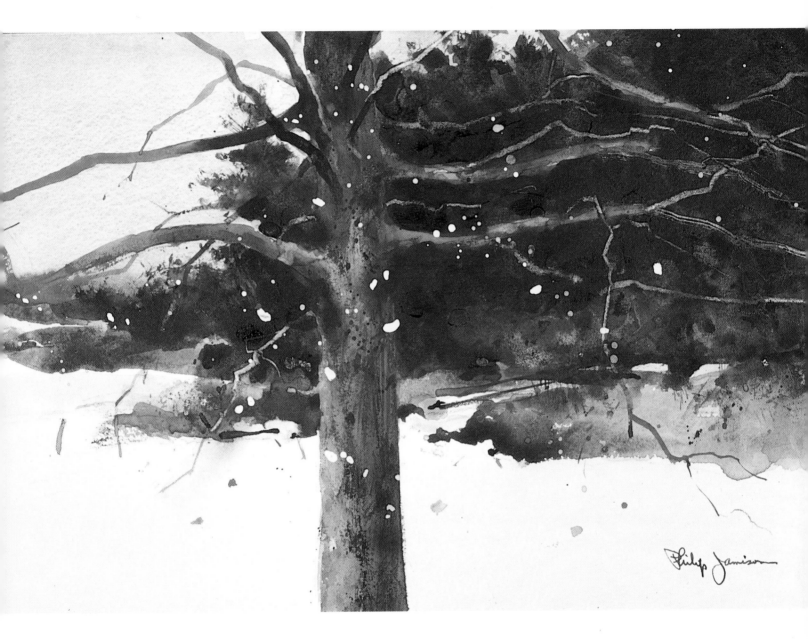

Two Vases of Daisies

Watercolor, 14½" x 19¼" (36.8 x 48.9 cm)

Step 1. This watercolor is going to be a "fun" painting. By this I mean I am starting out in a very loose, free manner without a particularly strong preconceived plan. Although I usually paint flowers from life, this watercolor is done from memory, and my intention is simply to give an impression of two vases of daisies.

I do very little preliminary drawing—just roughly suggest a few shapes with soft charcoal on a cold-pressed rag paper. I know that I will eventually want the daisies, and perhaps one of the vases, to be the whitest areas of the painting; so I first apply a cool wash of Davy's gray mixed with Payne's gray over the entire paper except for the area where the vases will be. While the paper is still wet, I drop in some spots of yellow ochre and raw sienna. When this dries, I remoisten the area that will eventually be flowers and flow in light and dark olive greens to suggest the foundation colors for the bouquets.

Step 2. In order to cover as much of the paper as possible right away, I paint the two vases using a mixture of Davy's gray, Payne's gray, and cerulean blue, allowing the colors to flow together freely. At the same time I wet a few areas of the background and drop in a touch of these same colors, along with some raw umber. I do this to create a feeling of air and space surrounding the flowers, and to eliminate the flat white background. Notice that I also tone down the area between the two vases so that it won't be so prominent. I begin to define the leaves just a bit, using olive green with traces of Vandyke brown. Because the vases seem very harsh at the bottom of the painting, I soften their lines and importance by suggesting a few leaves coming up from below. I also denote a number of yellow daisy centers here and there among the greens, using cadmium yellow mixed with a trace of permanent white.

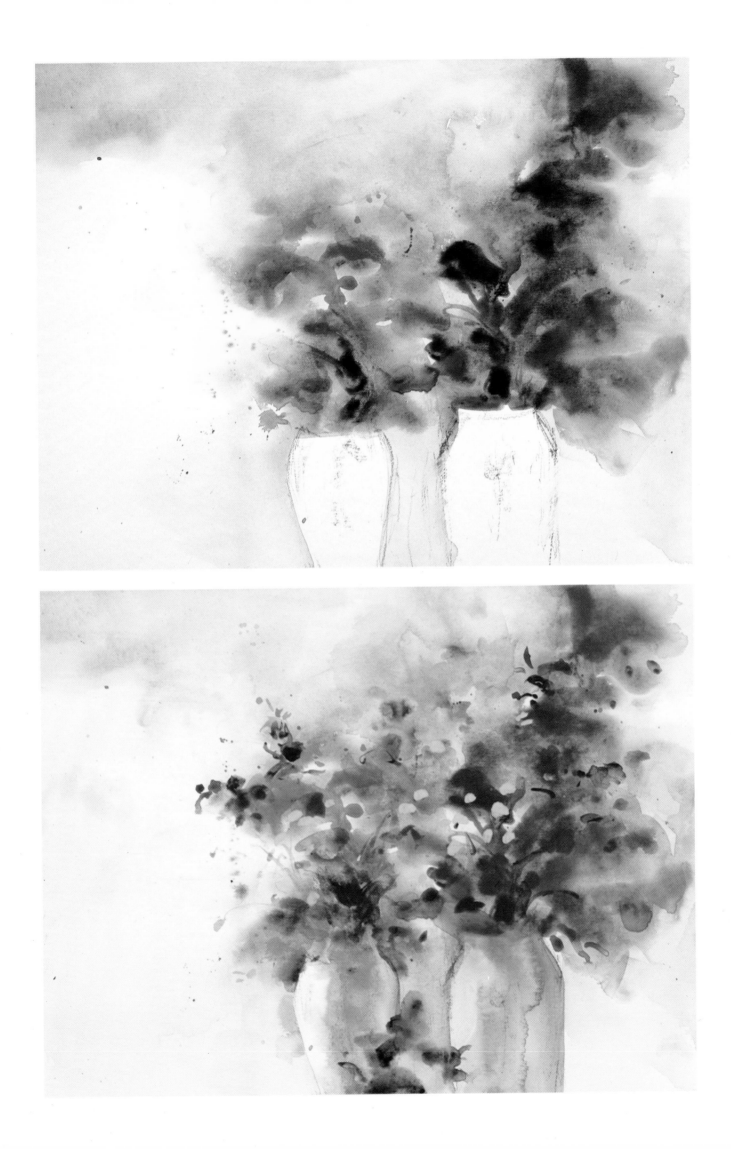

Step 3. At this stage, all of the large areas are established and I am anxious to put in some suggestion of daisies in order to give the painting a feeling of life. Because not all flowers or petals will be in full light, I use a mixture of permanent white and Davy's gray to portray the flowers that I want to be in partial shadow. Although I want to create the impression that the flowers have been very casually placed in the vase, their arrangement in the painting is of paramount importance to me, since these whites will form an integral part of the overall design.

Step 4. My chief concern now is to develop the flowers further and to give them a feeling of mass existing in space. To do this, I add a few more flowers and begin to mold their centers by adding shadows of burnt sienna and olive green. I paint in suggestions of stems and leaves, using a semiopaque mixture of olive greens and permanent white. At this point, I feel that the painting is somewhat lacking in color, so I add touches of Prussian and cerulean blue to represent bachelor buttons. These are applied with both a No. 8 sable brush and my finger.

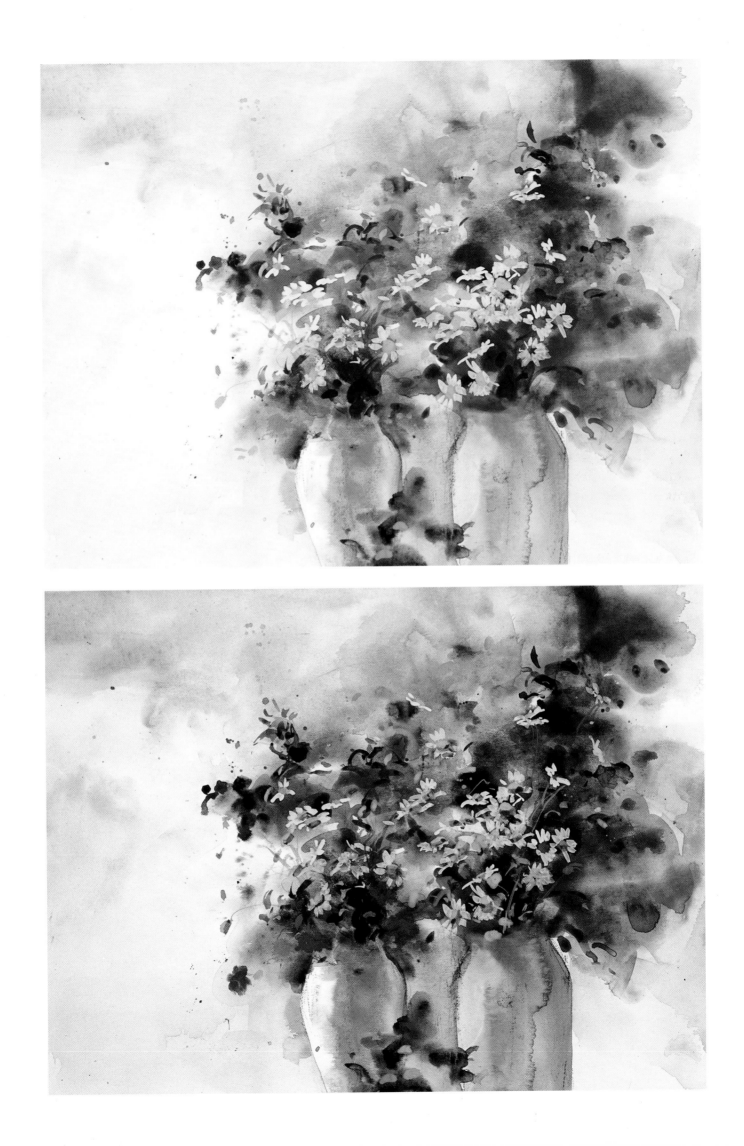

Step 5. I add more flowers to the composition, including several at the bottom of the paper. Continuously attempting to think in terms of light and form, I now concentrate on the flowers that will not be in shadow. I paint some daisy petals with pure permanent white, and others with permanent white tinted with cadmium yellow light, thereby giving a feeling of depth to the bouquets. Using a 2-inch flat brush, I quickly wet the background and put in a few tones of Davy's gray—especially in the lower left-hand corner, which I feel is overly white.

Step 6. In this final step, I consider the overall painting and begin to refine the larger areas, adding some detail as well. I wet a small natural sponge and remove several patches from the background, such as the warm area at top center, which I consider too prominent and not exactly the shape I prefer. I blend some of the greens and daisies together in a similar manner and subtly overpaint them with a semiopaque mixture of cadmium yellow, olive green, and a touch of permanent white. I apply the paint with a natural sponge as well as a No. 8 sable brush, in order to give the greens a textural feeling and to add warmth to the center of interest. I wipe out part of the right-hand vase with a moist brush and also darken its right edge with a cool mixture of primarily Payne's gray.

I add more flowers and refine others further by introducing a bit more detail—all the while, thinking of the watercolor as a *painting* rather than a literal picture of two vases of daisies.

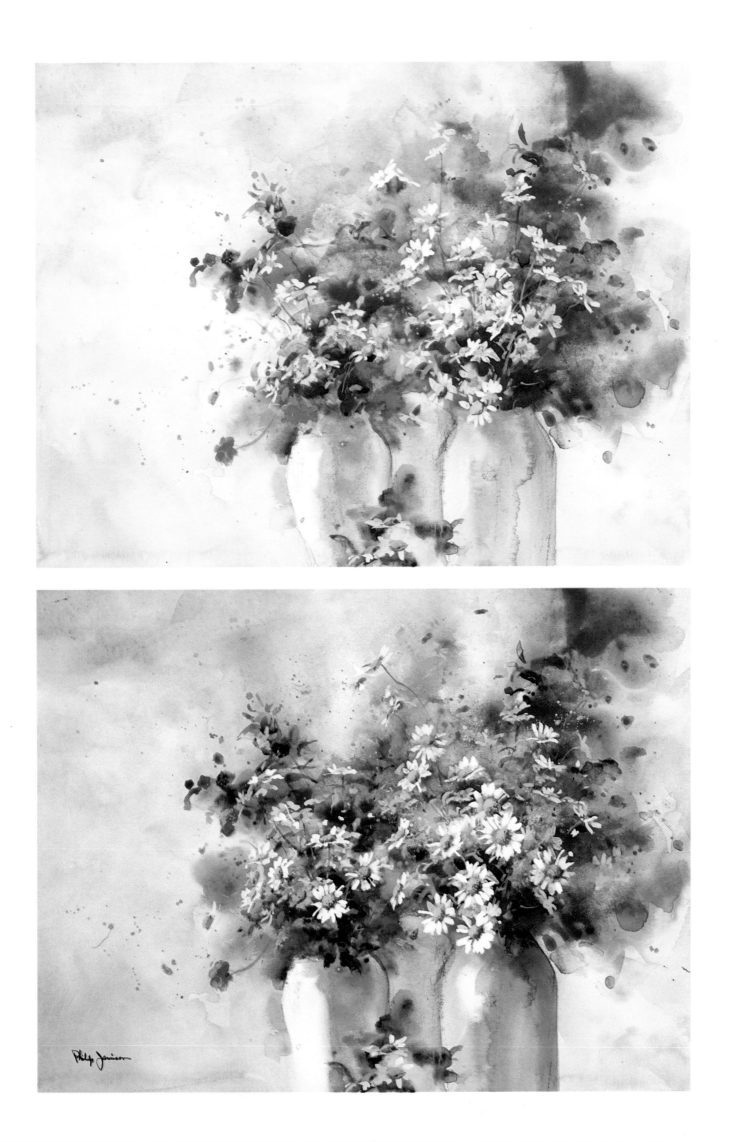

Field of Daisies

Watercolor, 7½″ x 10½″ (19.1 x 26.7 cm)

Step 1. In this small watercolor I want to give my impression of the numerous fields of daisies I have encountered over the many summers I have spent in Maine. It is done entirely from memory, and I wish to focus on the flowers themselves, with no other elements, such as sky, trees, or water, in the painting. My first concern is to paint the field itself; the flowers will come later. After dampening the entire paper—a sheet of 140-pound semirough—with a photographic sponge, I work wet-in-wet with yellow ochre, raw sienna, olive green, raw umber, and Vandyke brown in an attempt to create an overall impression of the grasses. I am primarily interested in color, but I also have a secondary interest in space—the receding horizontal plane of the field.

Step 2. The process I follow here is almost an exact duplication of Step 1. Again I work wet-in-wet, using yellow ochre, raw sienna, olive green, raw umber, and Vandyke brown—and again, I almost completely cover the paper. I am still trying to capture the "feel" of the grasses by building up layers of washes. Here and there I leave sharper edges where I don't wish the colors to run together completely.

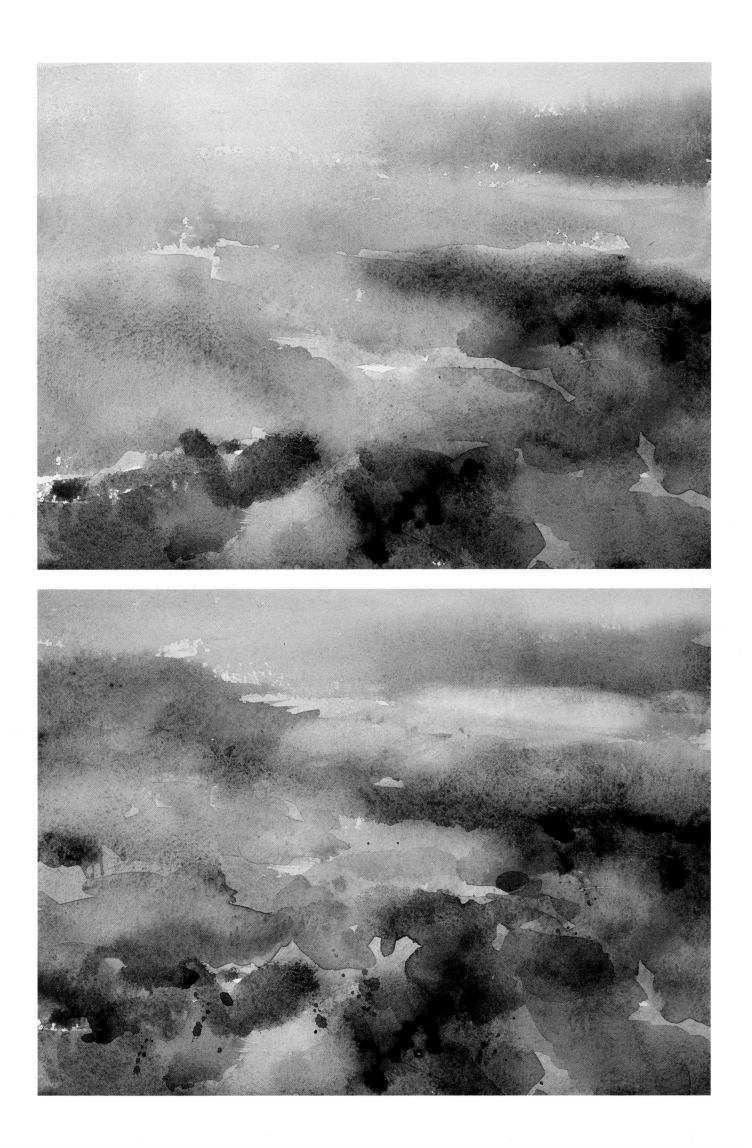

Step 3. Using a mixture of my two greens (olive and viridian) and my two browns (burnt sienna and Vandyke), I darken a few areas in the foreground, where I wish to center the interest. I next "spot-in" what will become the centers of daisies, using cadmium yellow laced with a little permanent white. I paint a few daisy petals in a warm Davy's gray to get a sense of where I am going in terms of establishing values, form, and a feeling of space. With my natural sponge, I suggest yellow flowers by applying a semiopaque blend of cadmium yellow pale and white. Here and there I brush in grassy stems and leaves, occasionally splashing and spattering the paint when I think things are getting too static.

Step 4. On the upper half of the paper I drop burnt sienna and olive green into small wet washes with a No. 4 sable brush, to give the field a little more solidity. I use burnt sienna and Vandyke brown here, partly to keep the green from becoming monotonous. I add more daisies and grasses as I feel my way along. I give form to the centers of the daisies by suggesting shaded areas with olive green and burnt sienna. The daisies that I wish to bring forward are painted with permanent white almost straight from the tube; for those in shadow, I use permanent white toned down with Davy's gray.

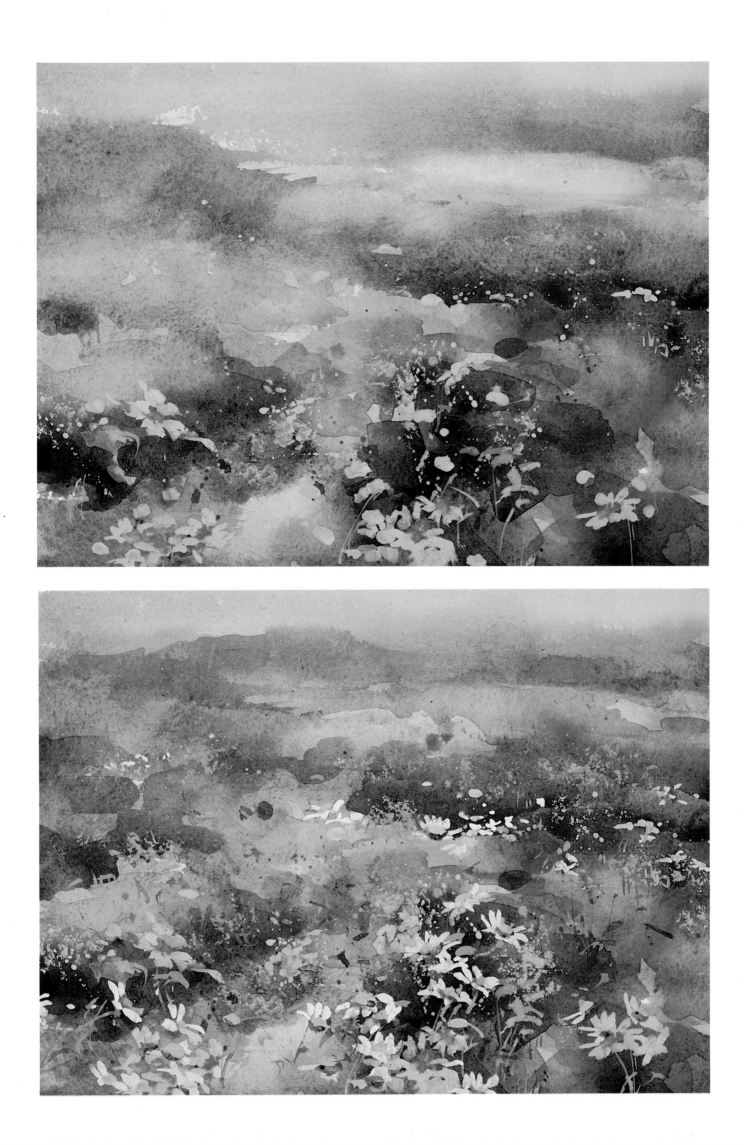

Step 5. In most of my paintings I concentrate on the overall abstract pattern. Although that is also a concern here, my main interest is color—not only the color I might actually see in a field of daisies, but also the color with which I want to compose my painting. In other words, I want my watercolor to be a *painting*—as opposed to a literal representation of a particular field. This is why I introduce the reds of the clover to complement the larger areas of green. To indicate the clover I use several opaque combinations of alizarin crimson, cadmium red, Payne's gray, and permanent white. I refine the daisies further by adding more detail. I want to unify the entire composition, and so I lighten some of the darker values in the upper part of the painting with a damp natural sponge, and, by smudging with the same sponge, blend together some of the adjacent areas.

Step 6. Following my intuitive feelings, as I usually do, I put some washes of olive green and Vandyke brown over the lighter areas in the center of the paper. But I decide that this is really no improvement, and so I sponge them right out again. I often add and subtract as I work in watercolor, and in many cases this procedure produces an end result quite different from my original idea. I complete this picture by going from area to area, placing more flower forms and refining them further until I am satisfied with the overall painting.

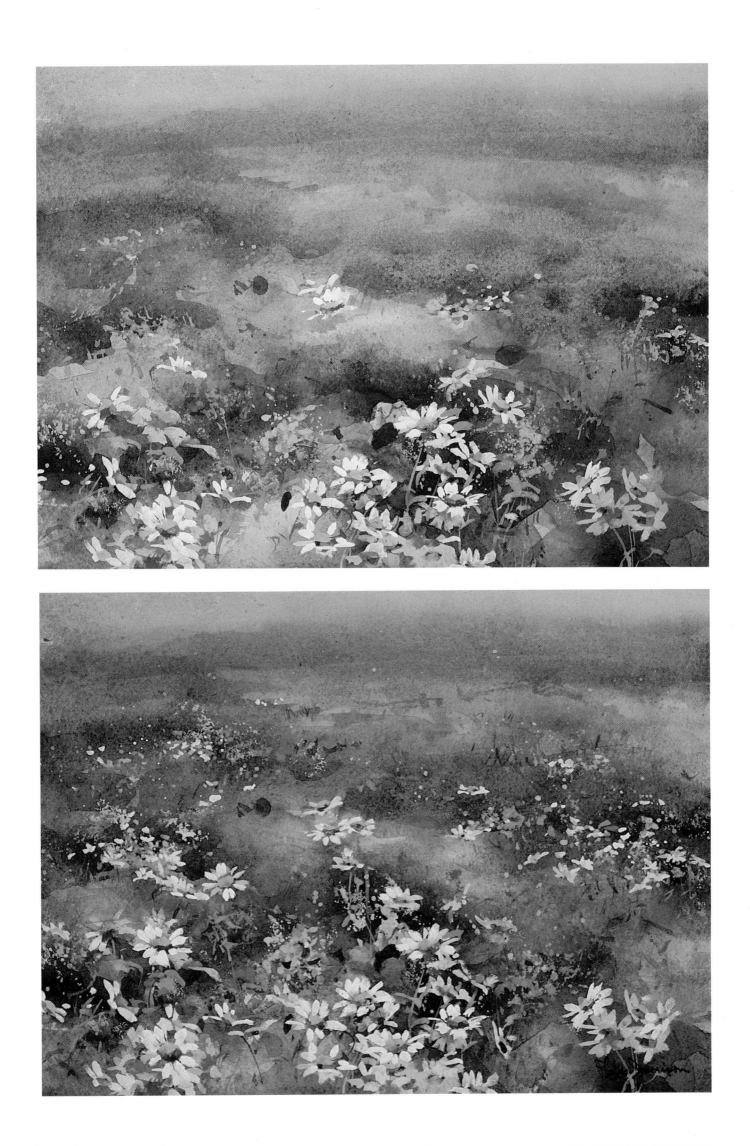

PART THREE

FIVE STUDIES

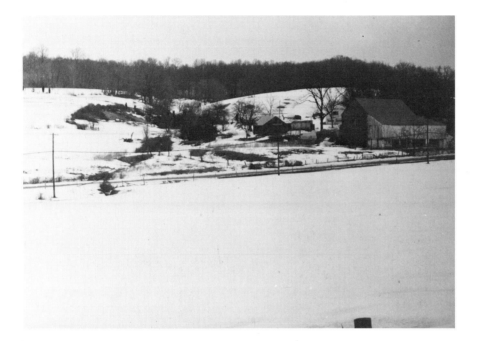

Occasionally, I paint a series of paintings based on the same subject. I never really plan to do this in advance—it just seems to happen when my interest is sufficiently aroused in a particular subject. Once I get started, it is often difficult to stop because one idea, or even a change in a painting, often inspires me to start another—almost like a chain reaction. At times I will even repeat the same composition, hoping to be able to improve it. When I have several watercolors in progress, I constantly compare one painting in the series with another. I find that a series gives me an opportunity to experiment, and at the same time, to study my subject in greater depth. The following five watercolors are part of a series I painted of a farm on Frank Road, near my home in West Chester, Pennsylvania.

The photograph at left shows only one of the vantage points from which I painted the following studies, which vary greatly in their treatment of the same subject.

Farm on Frank Road No. 1
Watercolor
12″ x 20″ (30.5 x 50.8 cm)

For this sketch I chose a smooth four-ply drawing paper which I like to use when I am trying to get the "feel" of a subject. It has a rather hard surface, and the paint seems to float on top of the paper rather than become absorbed by it. I find that this is an advantage when I wish to make changes because areas are so easily sponged out.

Initially, I laid-in a warm gray-green underlay wash to tone down the sky area. After this was dry, I brushed in the other large shapes quite directly, leaving both some hard edges and some soft ones. Because of the smoothness of the paper, most textures that I wanted had to be drybrushed over the washes later. In essence, this sketch consists of only two steps: applying the broad, wet washes first, and then adding drybrush detail over them. However, at a later date I did go back and change a few shapes to enhance the design—for example, I altered the pattern formed by the fields on the left.

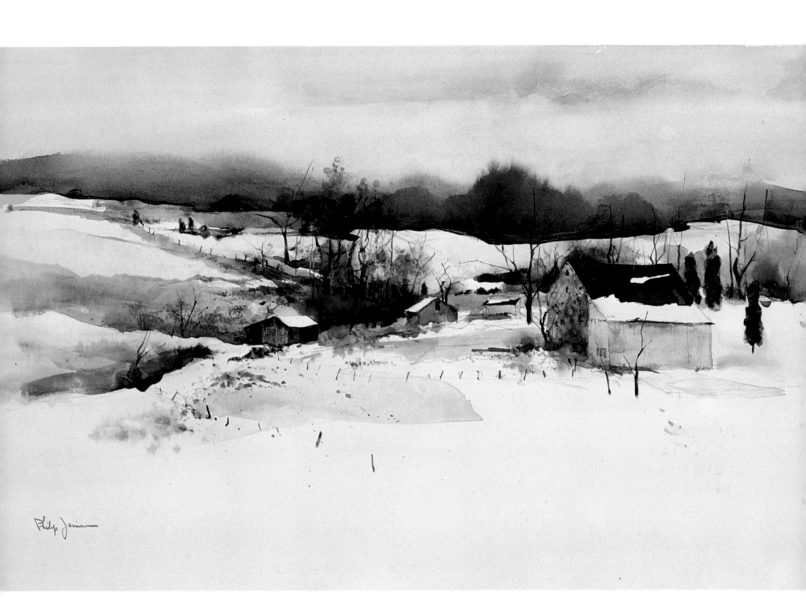

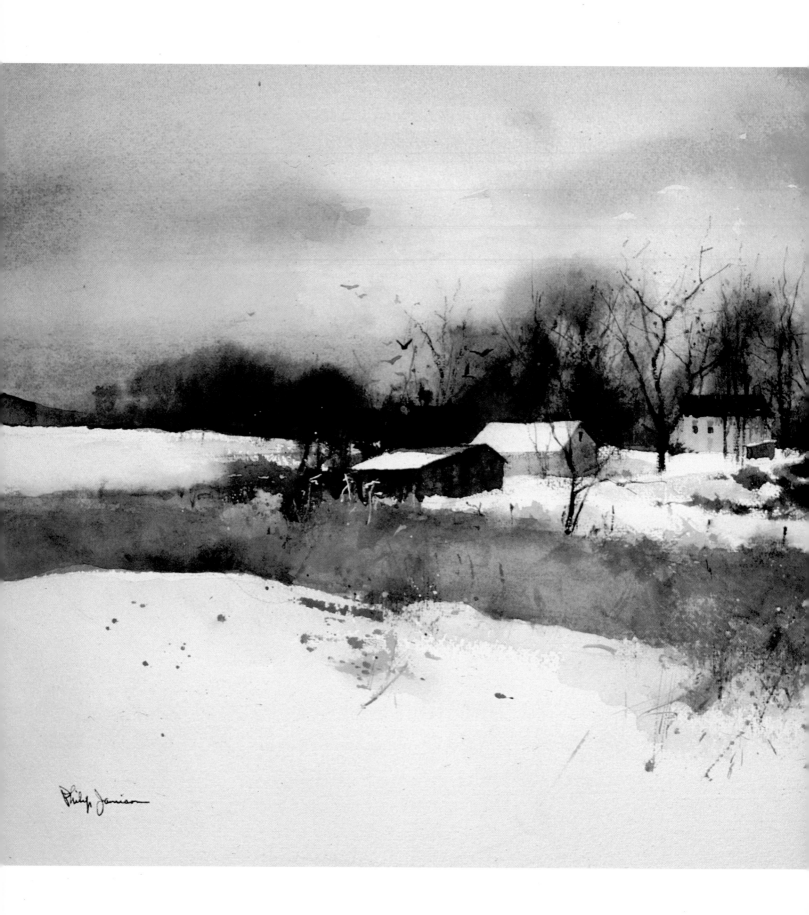

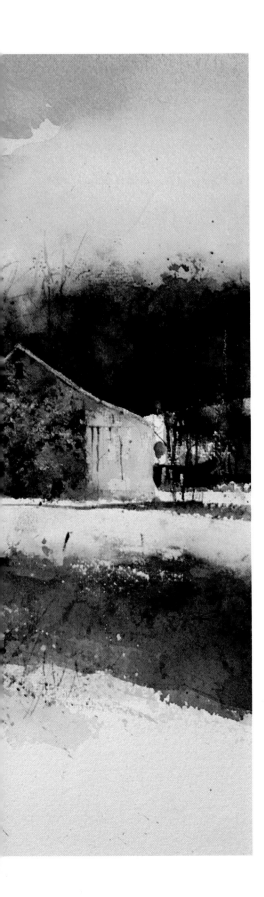

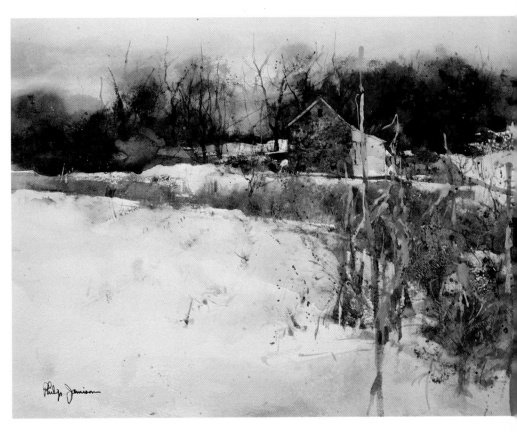

Farm on Frank Road No. 2 (left)
Watercolor
13″ x 19⅛″ (33 x 48.6 cm)

I stretched a piece of 140-pound semirough watercolor paper on a board to do this more sustained watercolor. As usual, I started by putting in a large, plain wash for the sky. After wetting the paper at the horizon line, I dropped in soft suggestions of trees using Davy's and Payne's grays. Next I applied the warm strip of grasses in an almost flat manner. Small washes were added next, to suggest the buildings and other areas of grass and brush. When I had defined all the large shapes, I went back and successively worked numerous layers of smaller washes into each area separately, in an attempt to create the various textures that I desired; but at the same time, I tried to keep the pattern simple. After the entire painting was finished, I added the cloud formations in order to enliven the sky area, which I felt was overly flat.

Of the five paintings in the series, this one is probably the most faithful to the farm itself. Most of the main elements of the original scene are included in the painting. However, they have been simplified and the shapes strengthened in order to create a stronger design.

Farm on Frank Road No. 3 (above)
Watercolor
10″ x 13½″ (25.4 x 34.3 cm)

For some reason, this unbalanced composition fascinated me. Thinking totally in terms of abstraction, I wanted the large area of snow in the left foreground—fully one third of the watercolor—to remain white. But if I wanted it to be consistent with the realistic quality of the painting, I could not just leave the paper blank. And so I applied some subtle washes of Davy's gray to suggest the receding plane of the snow and brushed in the merest hint of the rows of cornstalk stubs. I felt the center of interest was the old stone barn, which is quite small on the paper. To get to the barn visually, the eye must travel past the large expanse of corn in the right foreground. Therefore I treated the cornfield as one mass, using a number of layers of paint and always working to suggest the cornstalks and grass rather than portraying them in detail. As I painted this watercolor, I became very interested in the various textures—so much so that there is scarcely a space that hasn't been built up with many thin layers of paint. However, textures are used not only for their own sake, but also to mold form.

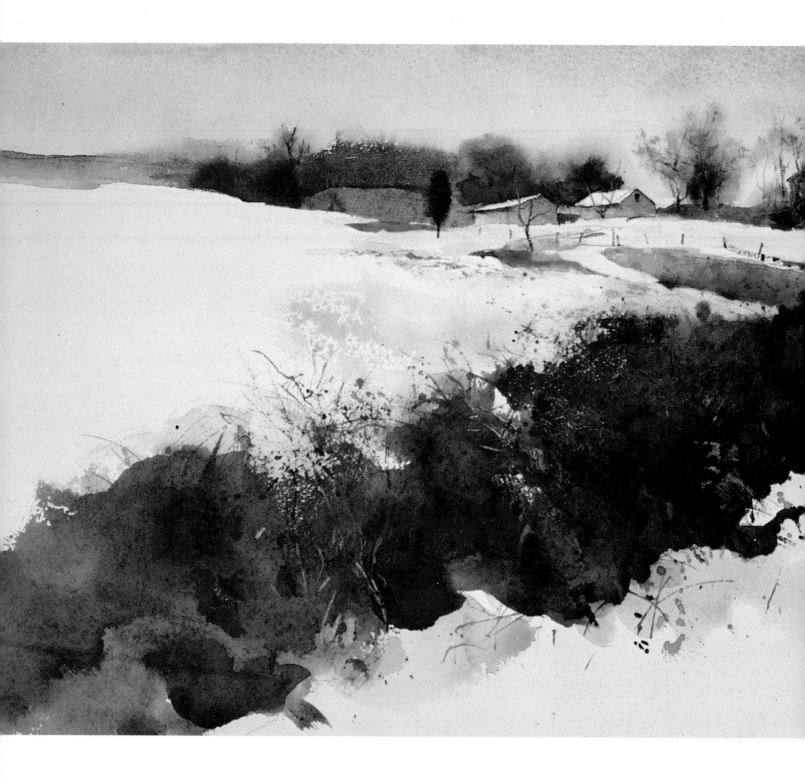

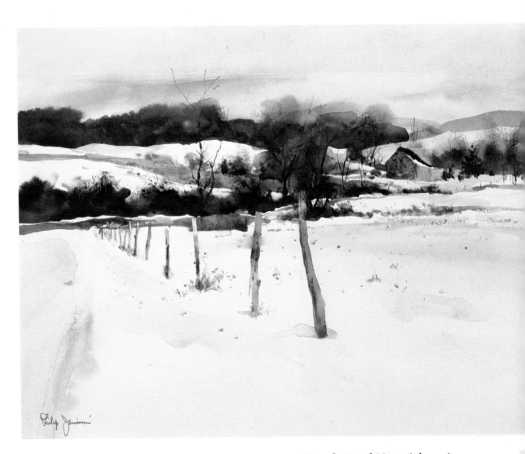

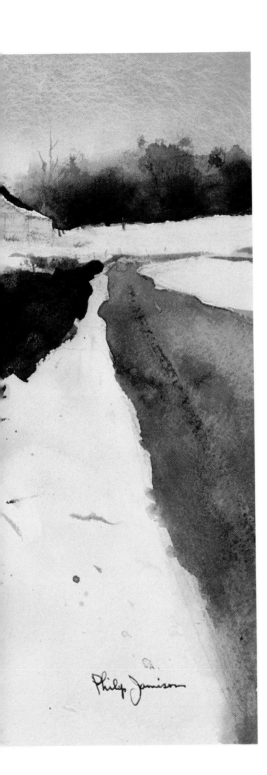

Farm on Frank Road No. 4 (left)
Watercolor
11″ x 18¾″ (27.9 x 47.6 cm)

The starting point for this painting was a compositional element: the almost overpowering diagonal hedgerow of brownish brush, which takes on the shape of an elongated triangle. And much to my surprise, when the watercolor was finished, I discovered that the entire land mass, as I had developed it, was completely made up of elongated triangles of various sizes. Once the initial watercolor was "completed," I made a number of changes—not by adding anything, but by subtracting. The uppermost strip, including the sky and farm buildings, remains direct and fresh and almost as I originally painted it. The same holds true for all of the painted parts. However, all the white areas but one were originally grass or had suggestions of grass within them. The resulting busyness disturbed me, and so I began scrubbing out these sections with a natural sponge in order to simplify them. What I achieved was a chain of white shapes that balance the darker triangles in a more dramatic way, lending additional strength to the overall composition.

Farm on Frank Road No. 5 (above)
Watercolor
10⅜″ x 13½″ (26.4 x 34 cm)

One winter day as I drove down Frank Road, my eye was drawn to a row of fence posts. I was intrigued by the starkness of these vertical shafts standing in the soft blanket of snow. As I proceeded to paint, I also became aware of the way these foreground verticals contrast with the background, which consists almost entirely of horizontal elements. As in the first painting in this series, I used a four-ply drawing paper. Of the entire sequence, this is certainly the most directly painted; in most sections, the actual brushstrokes can easily be observed. To strengthen and simplify the composition, I altered the actual scene by "covering" a foreground road with snow, eliminating some extraneous detail, and further emphasizing the horizontal shapes in the background.

PART FOUR

ONE MAN SHOW

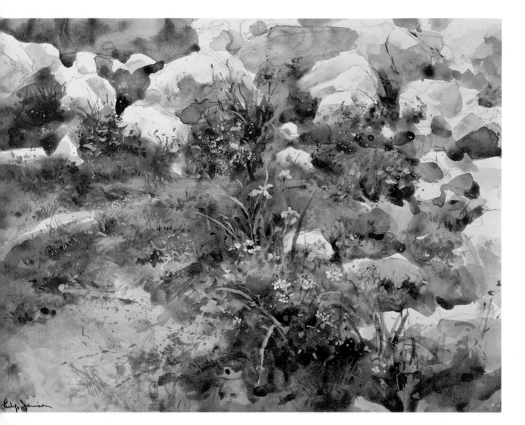

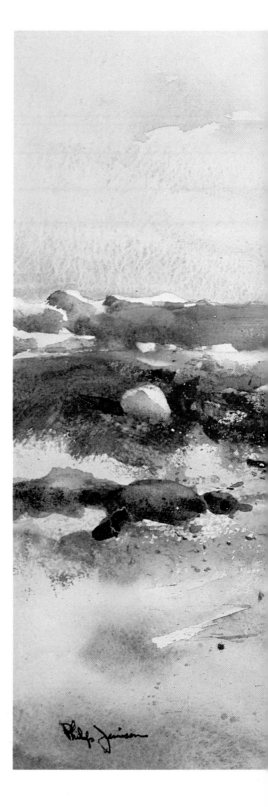

Wild Iris (above)
Watercolor
11½″ x 15½″ (29.2 x 39.4 cm)
Courtesy of the Janet Fleisher
Gallery, Philadelphia

This small patch of land is just a few feet from the ocean's edge. I passed by it and over it many times without really noticing it, but when I finally did it took on new meaning. It's strange how, when you give your complete attention to something small or insignificant, it can take on a much greater importance. It's often the familiar things we come in contact with every day that are so very important to us; and yet this same familiarity often makes us overlook them. So it is on the Maine coast, where such great panoramic views exist in all directions that we easily bypass the beauty at our feet.

Gulls at Grimes Point (right)
Watercolor
14″ x 22½″ (35.6 x 57.2 cm)

In 1975 I painted this watercolor at low tide on one of the many rocky beaches on our island. Without much afterthought, I had it framed and exhibited it in a show of mine at the Hirschl and Adler Galleries in New York City. I walked into the gallery alone one day and my eye was suddenly drawn to the two narrow strips of bright green and blue that run across the center of the watercolor. Although they probably weren't very noticeable to anyone else, those small areas of color sang out to me, and they haunted me long after I left the gallery. As I reflect back on that brief experience now, I realize that it has been the main reason for my increasing use of brighter colors from that day on.

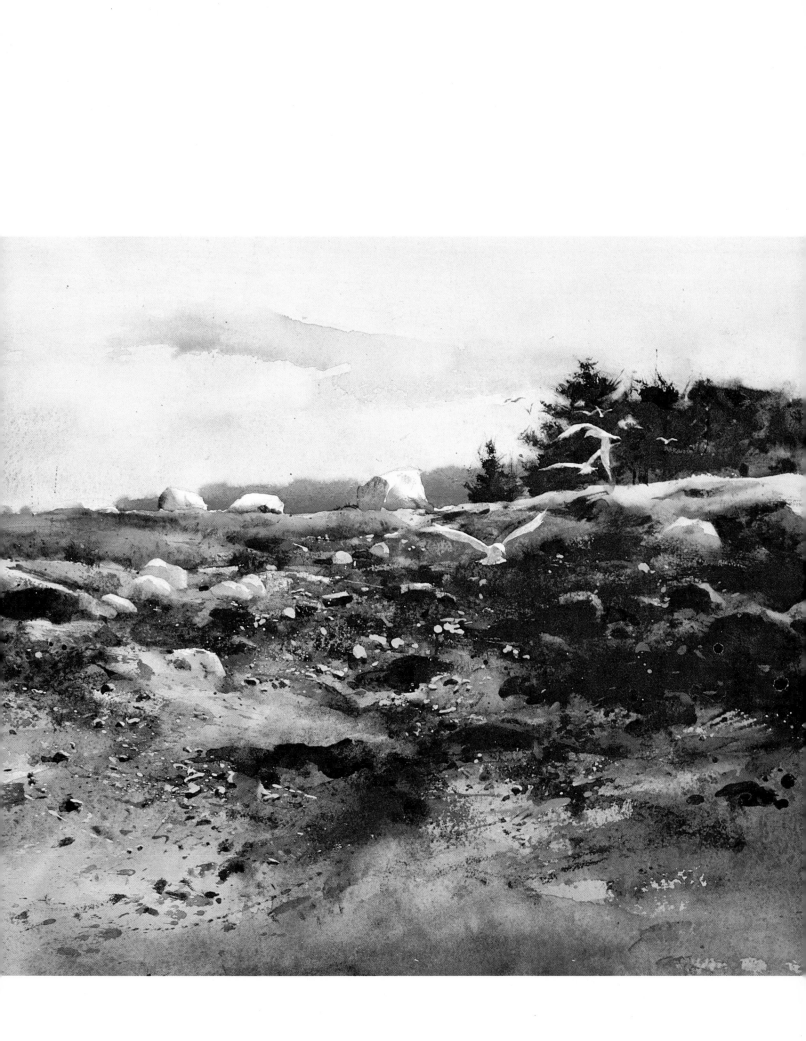

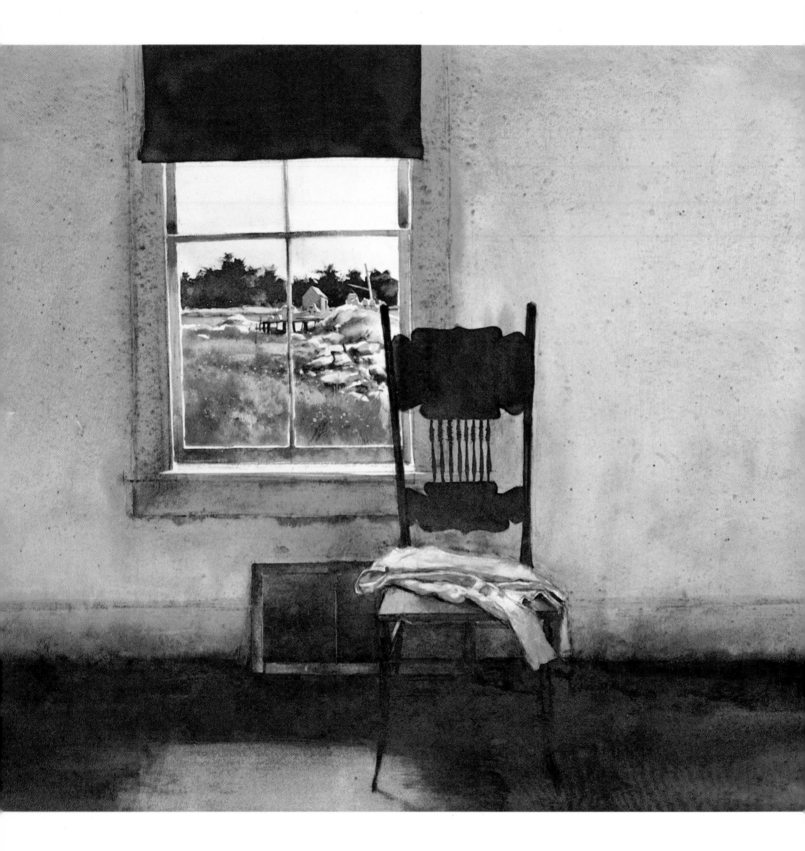

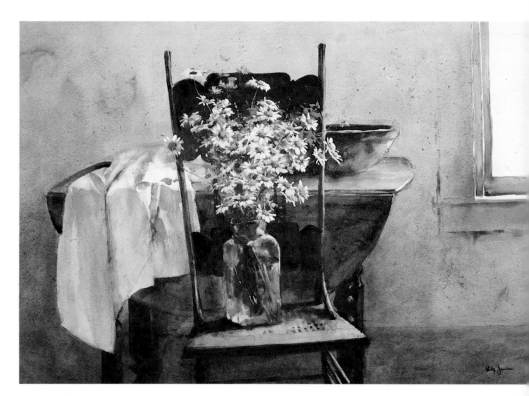

Studio Window (left)
Watercolor
19″ x 29″ (48.3 x 73.7 cm)

This rather stark composition is the west wall of my Maine studio. The distinctive turn-of-the-century chair is one of many we have in our home. Although they're not very comfortable, I find them fascinating, and they often appear in my paintings. The sweater on the chair—one of my rather threadbare sweatshirts, which I find so comfortable to work in—is one that just happened to be there. Ninety-five percent of the painting is completely neutral, providing a backdrop for the few square inches of color framed by the window.

June Bouquet (above)
Watercolor
18¾″ x 28½″ (47.6 x 72.4 cm)

Many of my still life and interior paintings are done directly from the subjects as I find them, haphazardly placed around the studio or elsewhere. At other times I arrange my subject specifically for a painting, as I did for this watercolor. When I painted it, I wanted the center of interest to be the vase of daisies; I introduced the other elements, such as the drapery and the white of the window, merely as shapes and values to enhance the composition.

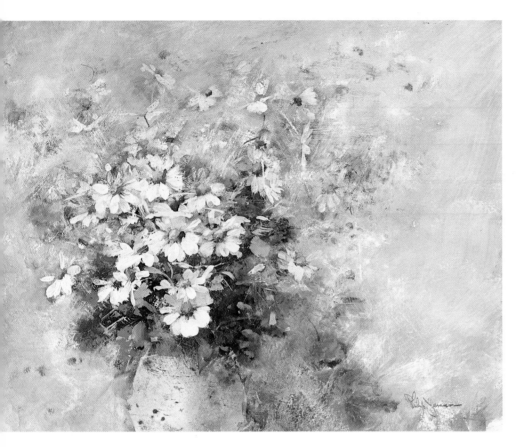

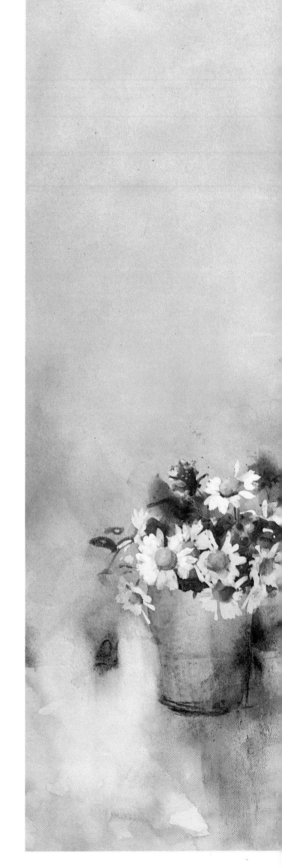

Daisies with Pink Background
(Above) Mixed media
10¾″ x 14″ (27.3 x 35.6 cm)

This painting belongs to a period in my painting which developed quite by accident. At the end of an oil painting session one day, I was intrigued by the color and pattern of the used paint left on my palette. I pressed a piece of paper on top of it and later, using this impression as a base, I developed the composition further with my oil paints until it resembled a rather impressionistic field of flowers.

I became even more interested in this method and began to use it in a more deliberate and preplanned way, occasionally adding other media besides oil. This painting is one of the later ones of that type. Initially I made an abstract monotype in oils, then worked over it in succession with oil, watercolor, and pastel.

Three Vases of Daisies (right)
Watercolor and charcoal
21″ x 29″ (53.3 x 73.6 cm)

Although this watercolor is not complicated by any means, I have probably spent as many hours on it as anything I have ever done. I first completed the painting around 1972. I had it framed and sent it to a show. When the picture was returned and I could see it with a fresh eye, I immediately took it out of its frame and reworked it. Again it was framed and sent out. When it was returned, I reworked it for the second time. This process was repeated yet a third time; and now, as I sit here writing this, I am gazing at it, unframed, and once again contemplating what I want to do.

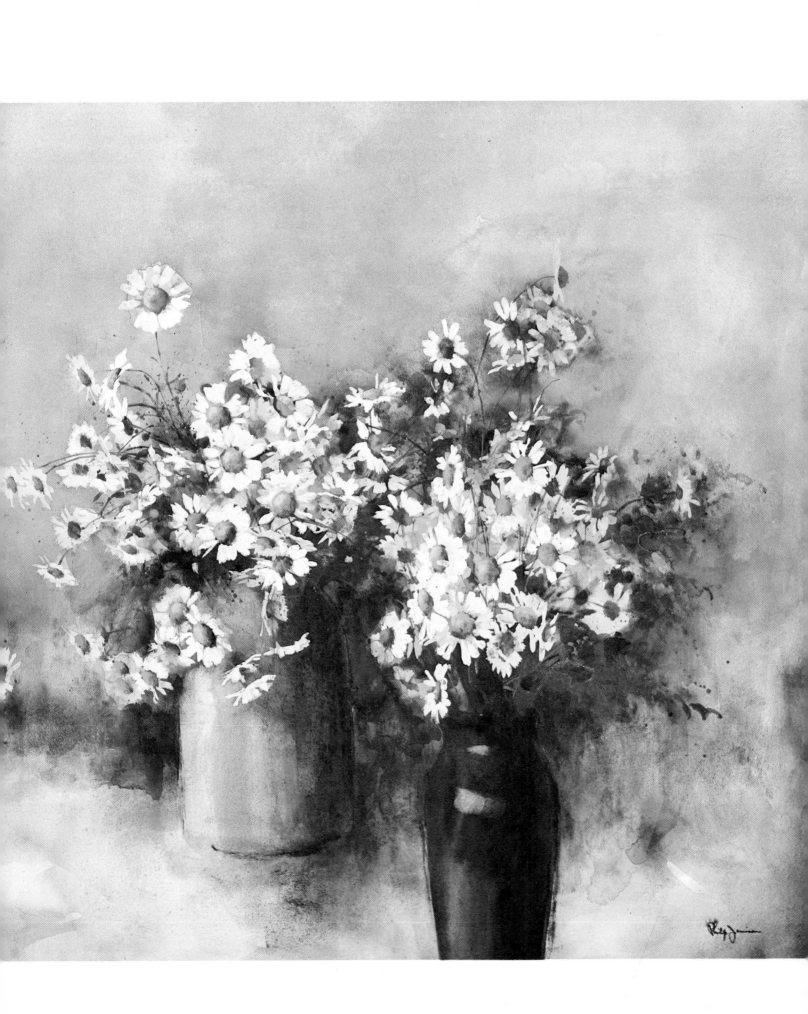

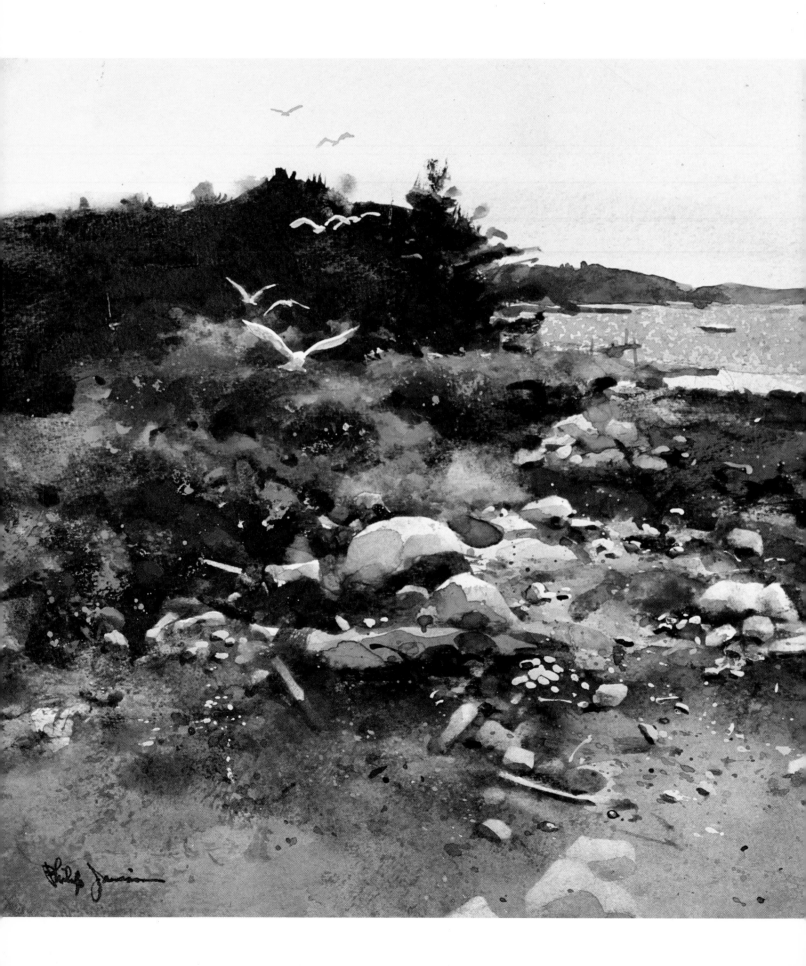

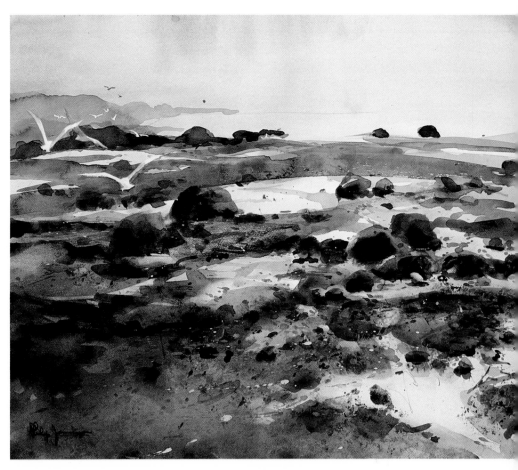

Up Seabreeze Way (left)
Watercolor
10½″ x 14½″ (26.7 x 36.8 cm)

With the exception of the sky, everything in this painting gave me trouble. I painted, scrubbed out, and repainted almost everything, trying to achieve the feeling I had when I first saw the marvelous textures created by the stones on the beach. I became very discouraged, but I persisted, working a little at a time for many weeks. I then buried the painting in a portfolio. When I came upon it again some months later, I was astonished to discover that I liked it.

Low Tide (above)
Watercolor
10½″ x 13¼″ (26.7 x 33.7 cm)

This is an early-morning view of some rocky clam flats just as the fog was beginning to lift. The stillness that morning was broken only by the piercing call of the gulls anxious for an early meal. It gave me an eerie feeling because it seemed not unlike a wet lunar landscape. The color, bordering on being monochromatic, changes quite subtly from the warm foreground tones to the cooler receding ones. The sky is both cool and warm at the same time. I painted this watercolor so rapidly that it might be considered just a prolonged sketch.

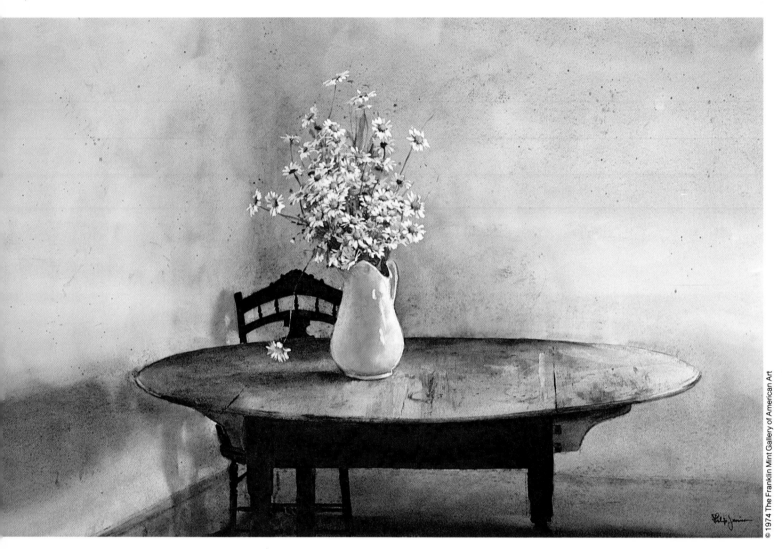

Daisies
Watercolor
18¼″ x 28″ (46.4 x 71.1 cm)

I can't remember when I painted my first daisy, but I do know that "daisy" must have been one of the first words I ever heard, because it was also my mother's name. During my art school days, she purchased Bridgeside, a picturesque inn on the island of Vinalhaven, Maine. Over many summer visits to the inn, I became enamored of the daisies which grow there in such profusion. And each June, as they make their annual debut in the fields, I renew my interest in these beautiful flowers. The white pitcher containing this bouquet is one that was used at Bridgeside for the better part of a century.

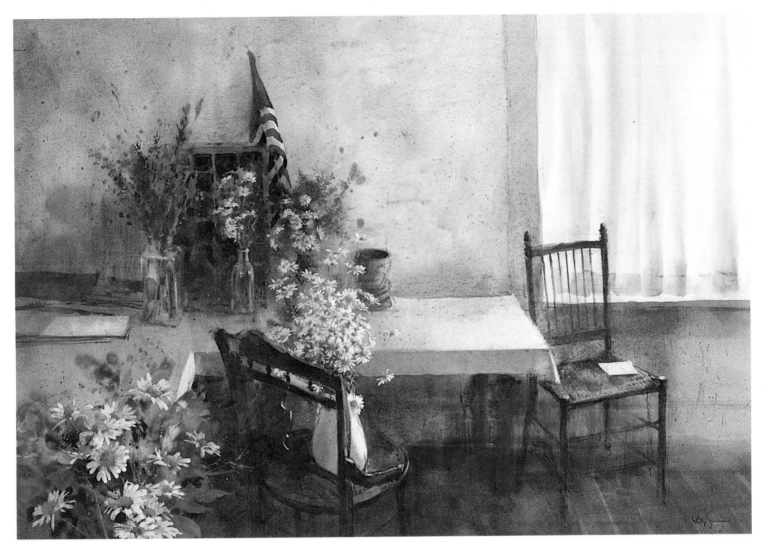

July (above)
Watercolor and charcoal
19¼" x 28¼" (48.9 x 71.8 cm)

The usual furnishings of my Maine studio are depicted in this painting, which was done some years ago. During June and early July the studio is full of the ever-present pitchers of daisies. The American flag, which provides the only note of color in this otherwise monochromatic painting, was placed there by one of our children after the island's most important annual event—the Fourth of July parade.

Honeybrook (overleaf)
Watercolor
12¼" x 21" (31.1 x 53.3 cm)
Collection of Patricia G. Powell

Honeybrook is a small rural town in Chester County, bordering on the Pennsylvania Amish country. As I drove through it one snowy day, I was attracted by the jewellike quality of the town in the snow. The varied shapes of the buildings and signs, along with the staggered dark verticals of the telephone poles, created a fascinating pattern against the light snow and sky. The snow simplifies the foreground, enhancing the importance and interest of the pattern.

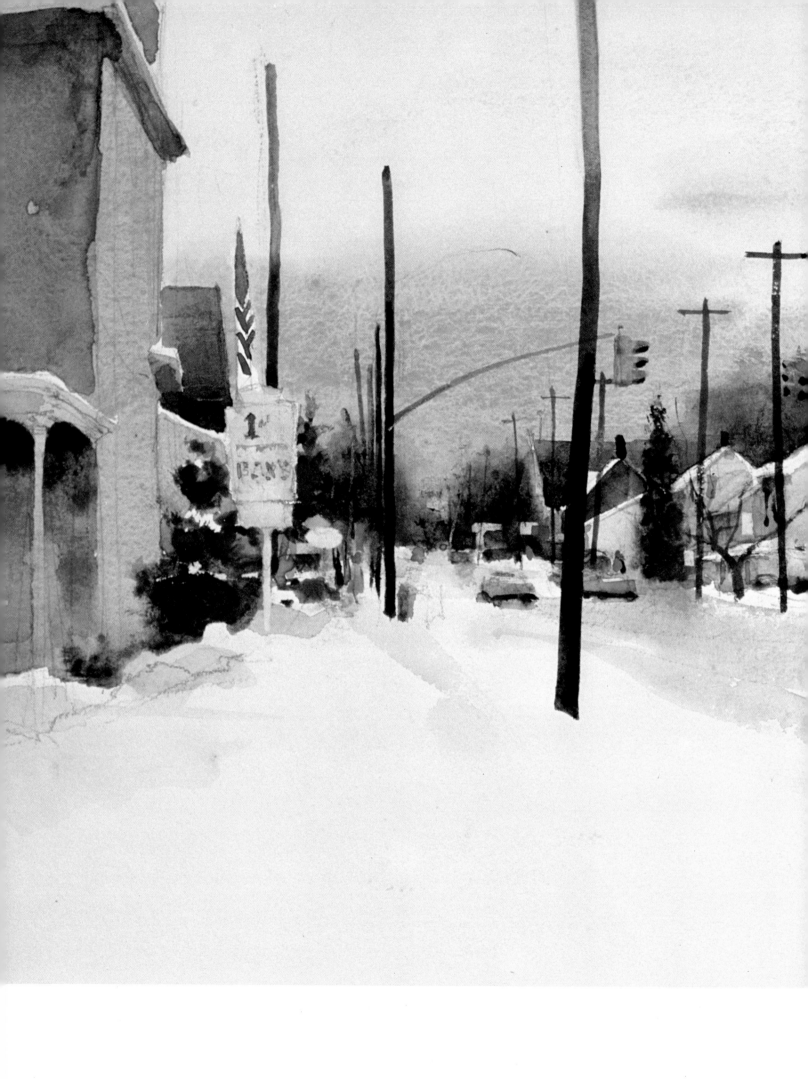

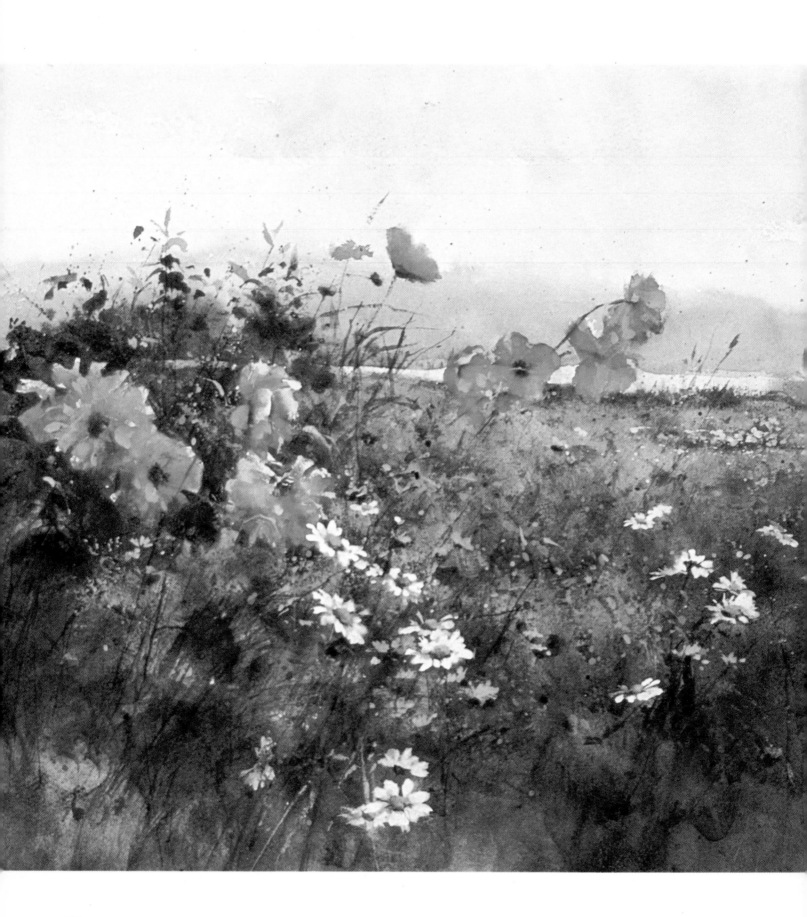

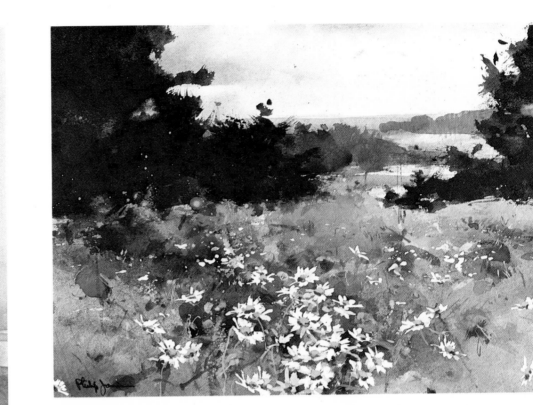

Field Poppies (left)
Watercolor
13½″ x 19½″ (34.3 x 49.5 cm)
Courtesy of Aaron Ashley, Inc.

It was early in the season and the Raphael Soyers had not yet arrived on Vinalhaven for the summer when I discovered these poppies growing among the tall grasses surrounding their early—New England frame house. They seemed so brilliant, and slightly out of character, against the fog-shrouded water in the distance. Because of this, and the fact that they almost seemed to float above the grasses, I wanted to paint them.

Ambrust Hill Daisy Field (above)
Watercolor
9″ x 13½″ (22.9 x 34.3 cm)

This watercolor was originally a sketch of a view overlooking the harbor on our island. I painted it on the spot and was less than enthused about it when I returned to the studio. I filed it away in a portfolio, where it remained for a year or two. I came across it one day and decided to have a little fun "slopping around" with it. Most of the painting was either scrubbed out or reworked—in fact, the only elements of the original sketch that remain are the water and the distant spits of land. Everything else was added later, including the flowers and the dark pines. What I have done, in essence, is to turn a more or less reportorial sketch into an almost completely imaginary watercolor.

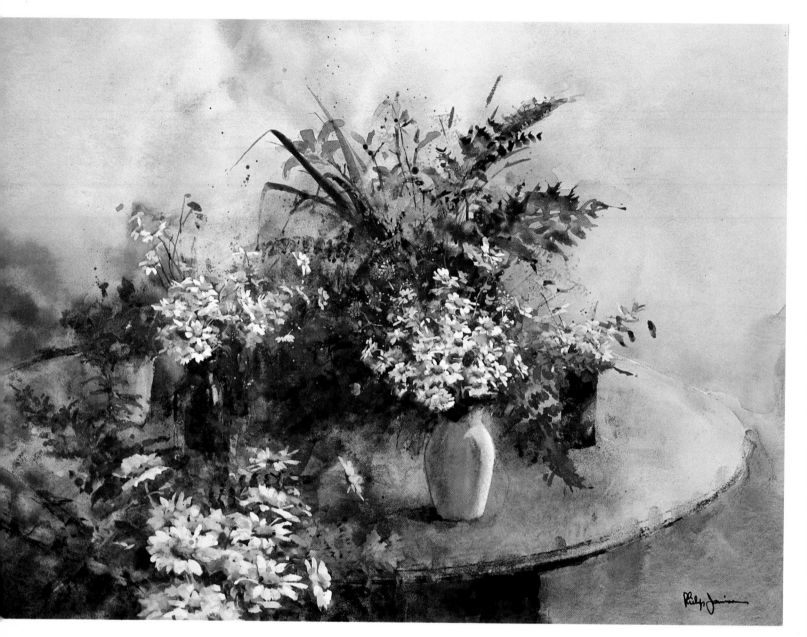

My Studio in July
Watercolor
14″ x 19″ (35.6 x 48.3 cm)

This dated oak table with its finish completely worn off holds a fascination for me. It seems to move around the house and is currently being used as our dining table in the Maine kitchen. When I did this watercolor it was my favorite table for still life painting and on it was a myriad variety of flowers, running the gamut from clover to day lilies. I used charcoal intermittently during the painting process to "feel out" various forms as I went along. Since charcoal is easily rubbed off, very little of it remains in the finished painting.

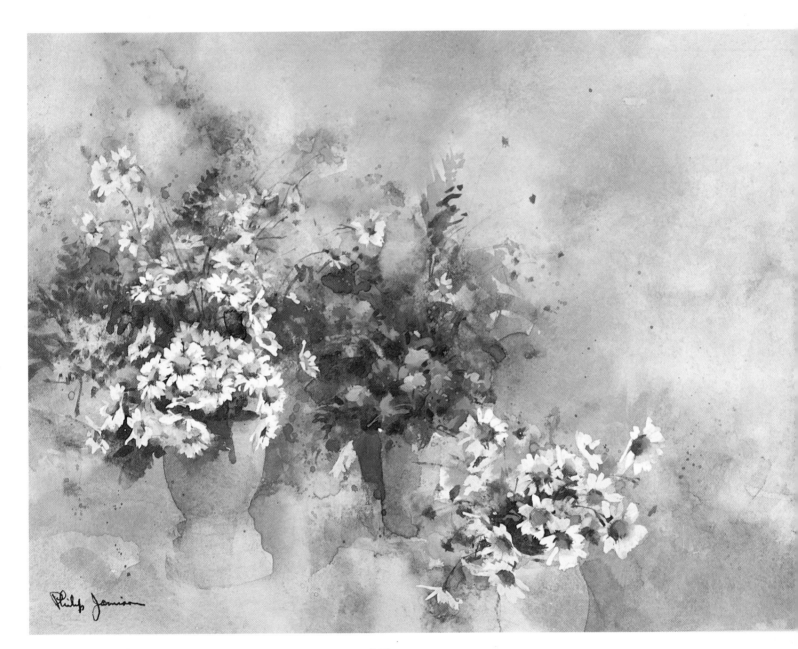

Daisies and Clover
Watercolor
10¼" x 13⅞" (26 x 35.2 cm)

One summer day after I had just completed a large watercolor and the studio was still brimming with vases of flowers, I began this small painting as a relaxing exercise. Without any preliminary planning, I simply began to paint a vase of daisies. As the painting progressed, I decided I wanted the flowers to seem as if they were almost floating in space. My major problem in doing this was controlling the background space—that is, keeping it devoid of subject matter without its seeming "empty."

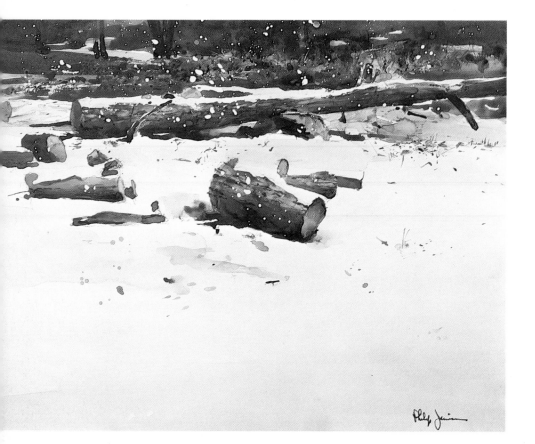

Cary's Logs (above)
Watercolor
10¾" x 14" (27.3 x 35.6 cm)

This painting was made as a study for a larger painting—or perhaps it would be more accurate to say I did this watercolor and then did a larger painting from it. At any rate, my next-door neighbor had felled a locust tree for firewood. It lay by his house for months, and I paid little attention to it until one day it snowed. A snowfall seems to bring a hush over the countryside, and this quietness, along with the pattern created by the white blanket, brought the felled tree vividly to my attention. I purposely painted the subject at the top of the paper, leaving the large white space below to suggest the aloneness and closeness to nature that one feels while tramping through newly fallen snow.

Sheller's Farm (right)
Watercolor
7⅛" x 10¼" (18.1 x 26 cm)

Over the years I have painted a number of watercolors of this time-honored Chester County working farm, which has changed little during my lifetime. This painting, one of my earlier studies of the farm, started out as a pencil sketch for a larger painting, but I became so interested in the sketch that I added color and completed it. I never did get around to the larger work.

Logan Circle
Watercolor and charcoal
9½″ x 22″ (24.1 x 55.8 cm)
Collection of Mr. and Mrs.
John L. Hall

This painting of St. Peter's Cathedral with the Philadelphia skyline in the background was done in 1962. A year or two prior to this painting, I had taken a watercolor that was completely unsatisfying to me and, without much forethought, begun to work over it with charcoal. The effect was pleasing to me and so, as time went on, I began to incorporate charcoal into many of my paintings. This is one of them, and it is probably one of my simplest works, considering the amount of subject matter in the actual scene; just about everything is reduced to a bare minimum. My main concern was to give an ethereal feeling to the city as I visualized it in my mind. I wanted to suggest the city without actually depicting all of its intricacies. The gray "wash" of charcoal over the already-muted colors of the underpainting assists in achieving this effect.

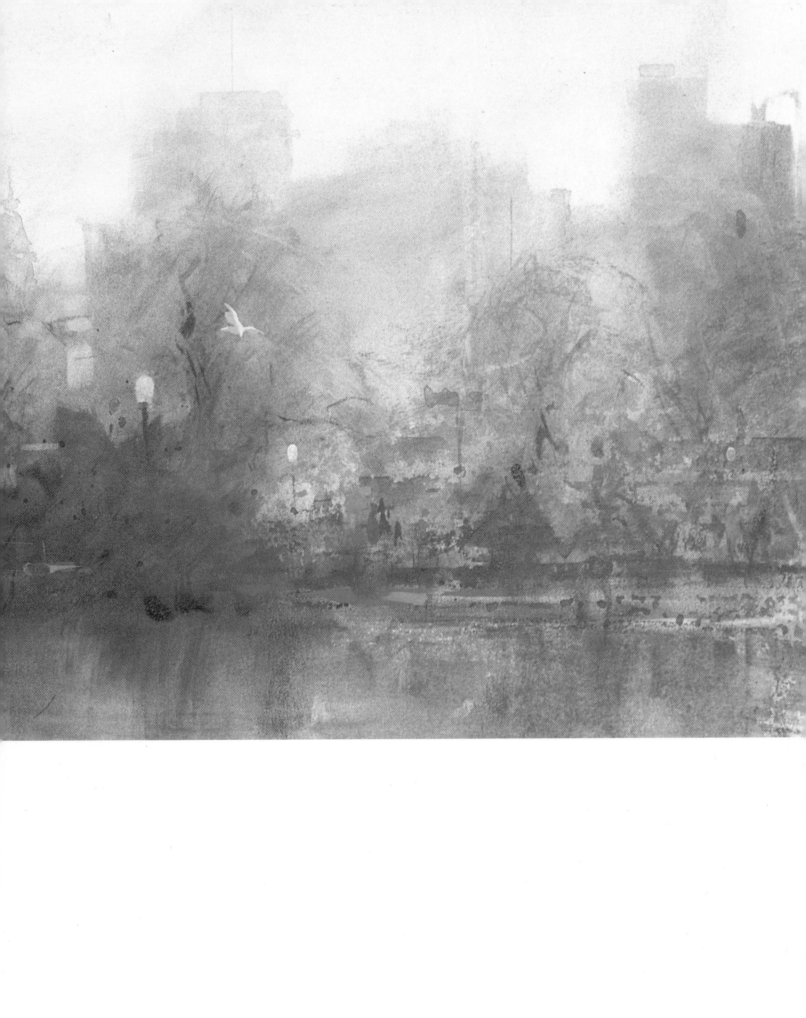

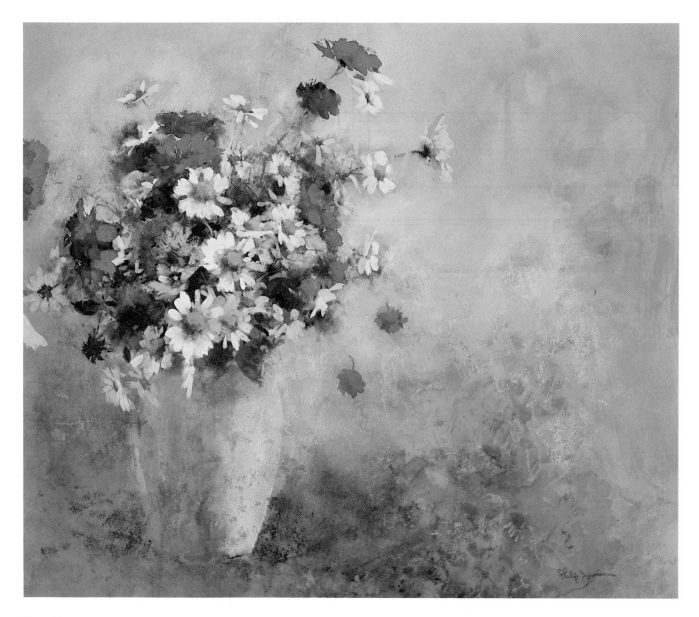

Two Seasons
Watercolor and pastel
19″ x 22″ (48.3 x 55.9 cm)
Collection of D. F. Mahoney, Jr.

As I have said earlier in this book, I like to paint realistically, but not necessarily literally. Upon seeing this painting, a lady who was obviously a "garden-clubber" remarked to me, "How could you possibly do this painting when the flowers you have in the vase don't bloom at the same time of the year?" She was correct, of course, but it never dawned on me that anyone would look at a painting and say that. I found her remark amusing, and whimsically gave the painting its present title. I guess to this day that lady has no idea that a painter can do anything he pleases—call it artistic license, esthetics, or just plain dreaming.

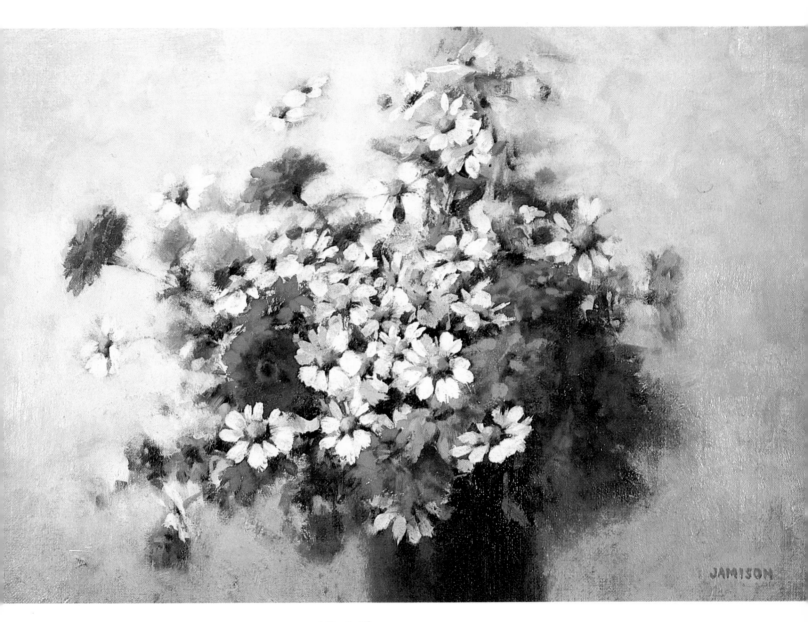

Alice's Flowers
Oil on canvas
9¾″ x 14¼″ (24.8 x 36.2 cm)

Although I am primarily a water-colorist, I love art in any medium. On occasion I am drawn back to my oil paints, which I employ chiefly to paint flowers. Oils don't seem to require quite the frantic pace that watercolors often do, so for me, it can be a pleasant change. My mental approach, however, remains the same, al-though the means of applying the paint are obviously different. It doesn't seem inappropriate to in-clude an oil painting in this water-color book, since, through my painting in oils, I have actually found a number of ways to im-prove my watercolor methods—especially the way I handle stronger colors and space.

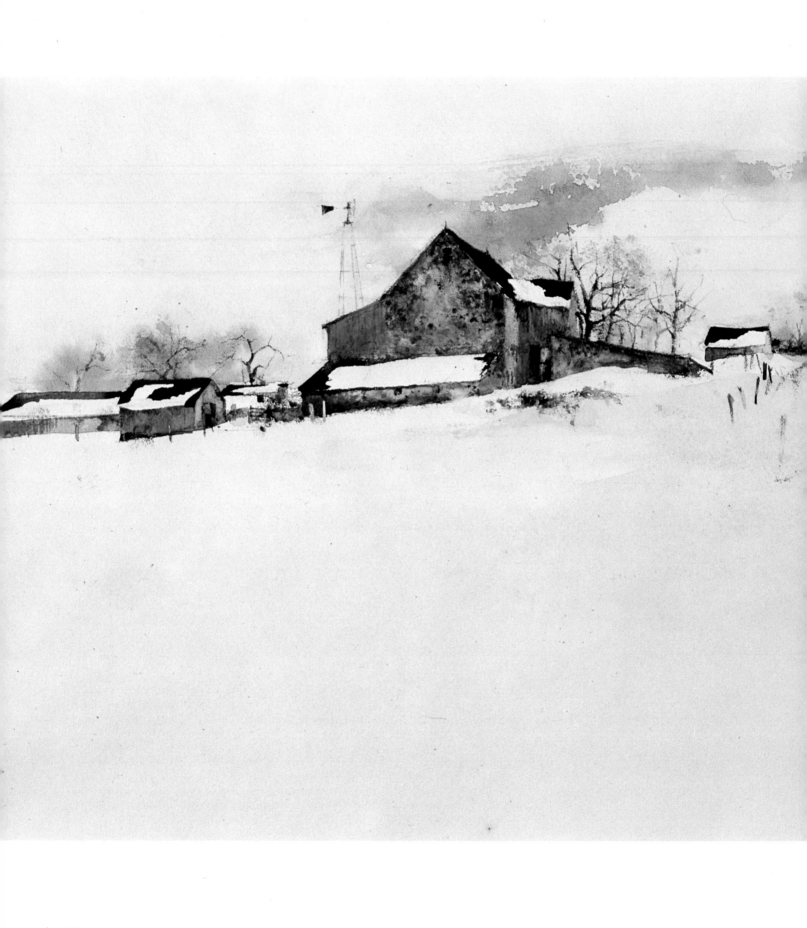

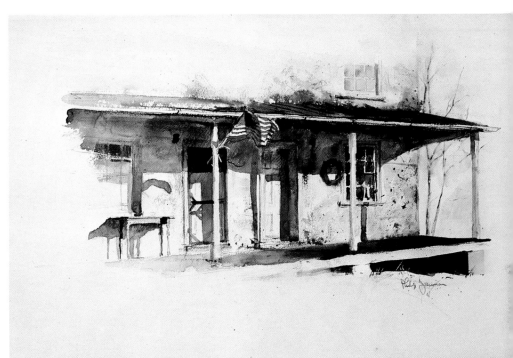

The Davis Farm (left)
Watercolor
9″ x 13⅝″ (22.9 x 34.6 cm)

This delightful farm stands like a last bastion against the urban sprawl between Philadelphia and Wilmington. In winter it sits majestically surrounded entirely by open fields. On this day I was intrigued not only by the shapes of the buildings, but also by the snowy shapes on the roofs, which contrasted with the delicacy of the trees and windmill. Here, as in other paintings where most of the paper is quite plain, I gave particular attention to the shape of the cloud formation in the sky. Its shape and texture are midway between those of the buildings and the stark, white snow in the foreground.

Chris Sanderson's Front Porch
(Above) Watercolor
9¼″ x 15¼″ (23.5 x 38.7 cm)
Collection of Mr. and Mrs.
Joseph W. Strode, Jr.

Chris Sanderson, a beloved local historian, lived in this house. One January day my eye was caught by a marvelous green wreath hanging against the whitewashed stone wall. I started a painting of it several days later. Since it was well after Christmas and I was afraid the wreath might be removed soon, I asked Chris if he would be kind enough to leave it hanging a bit longer so that I could complete my painting. He obliged, and I finished the painting. Two years later, in November, I noticed an American flag fluttering from the front porch, and nestled against the wall was this same wreath—but time had changed its cheery greens and reds to a death-like brown. That day, I painted this small watercolor. The following day Chris died.

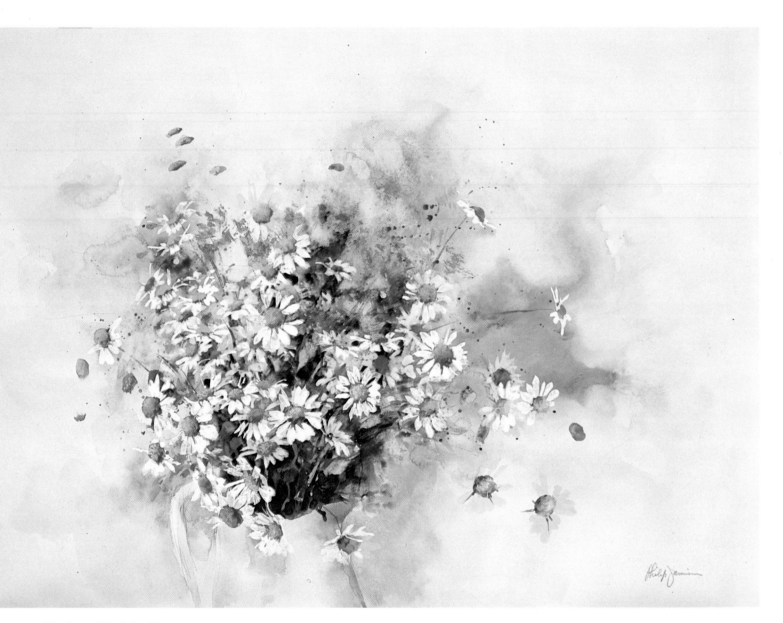

Pitcher of Daisies No. 1
Watercolor
13⅜″ x 18½″ (34 x 47 cm)
Collection of Mr. and Mrs.
Jerome B. Gray

This painting was done on one of those beautiful old sheets of Whatman paper, which are so rare a find these days. It happened to be a very smooth 72-pound drawing paper, which usually buckles too much when used with watercolor. Nevertheless, I enjoy using it for some of my flower paintings. After floating-in background washes of warm and cool grays, I painted the daisies by working alternately with a sponge and brush. To give the flowers a spiritual quality, I painted them in a starburstlike pattern.

November Daisies (left)
Watercolor
9⅝" x 13" (24.5 x 33 cm)
Collection of Alice Gray

My wife's sister, Alice Gray, arrived at the studio one wintry day with a most unexpected gift—a clump of small daisies in an earthen pot. Attached to it was the following poem, which she had written to me:

Plea from a Daisy found blooming in November

I'm shy and plain
And who doth love me
Hiding 'mid the roadside weeds?
The gray November skies above me
Toss the silver milkweed seeds.

Oh, will he come
Before the snow flies
To pluck me from my earthy floor
And with his gentle, magic fingers
Make me beloved ever more?

I shed a tear or two over her thoughtful gift, and then painted this picture.

Bridgeside Porch (overleaf)
Watercolor
19" x 29" (48.3 x 73.7 cm)

This is the third of four paintings of the porch of my mother's inn, Bridgeside, on Vinalhaven, Maine. The inn has all of the charm of a bygone era, and the porch itself actually overhangs the waters of Indian Creek. It holds a lot of memories for me. As our children were growing up we spent many a happy time here, playing games or just enjoying the changing weather and the view from this delightful glass-enclosed room. As I reflect back on doing the paintings of Bridgeside's porch, I realize that, in spite of many things that ordinarily would have posed problems, all four came very easily, perhaps because I was so absorbed in my painting and because the subject itself meant so much to me.

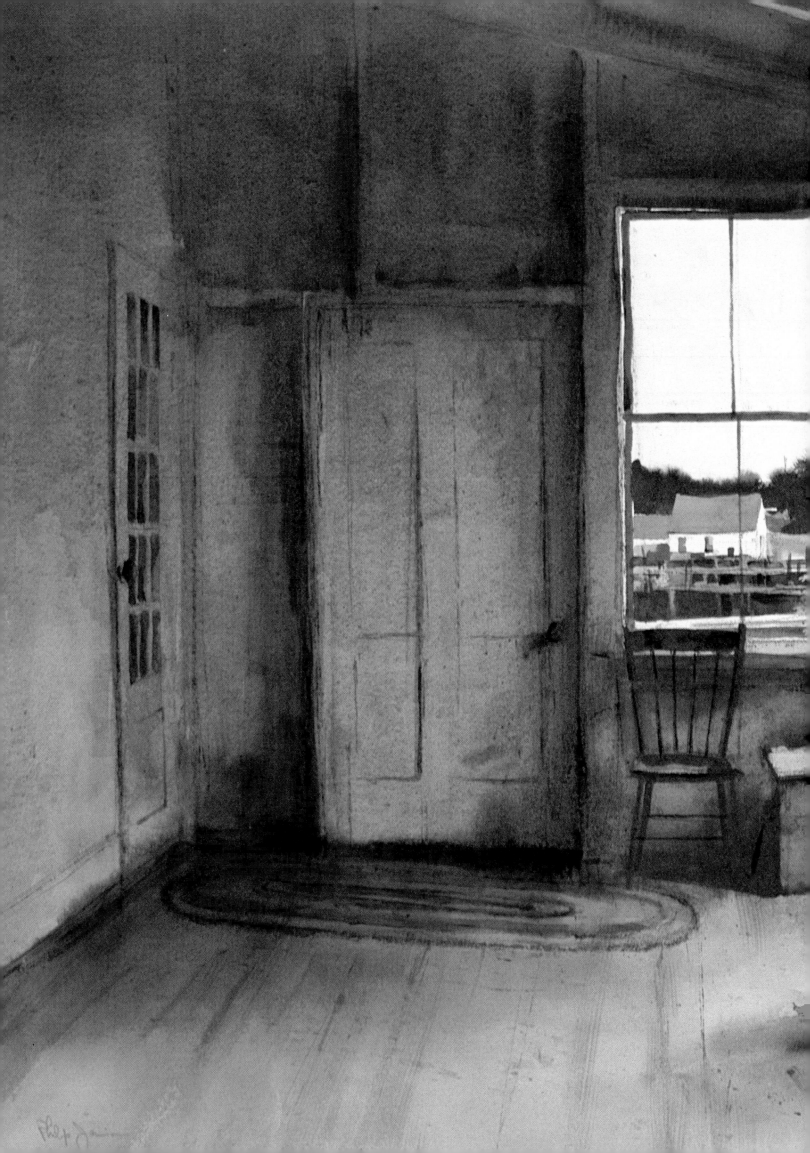

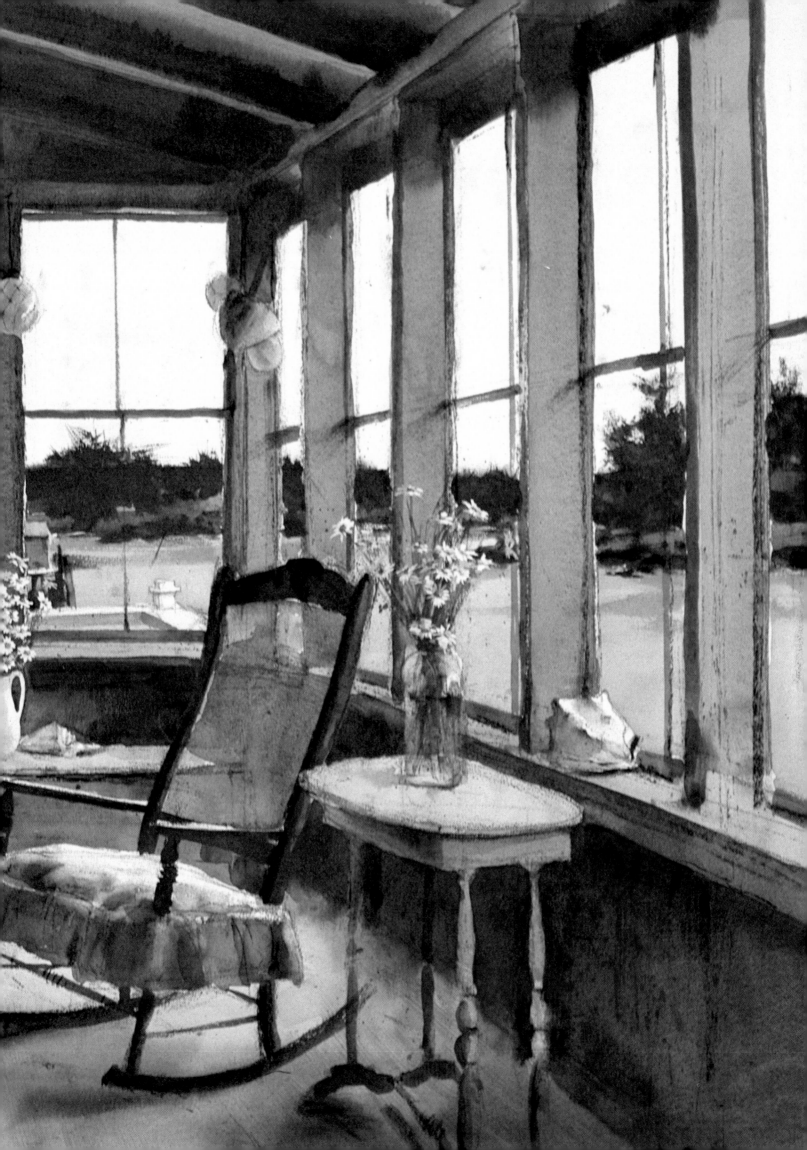

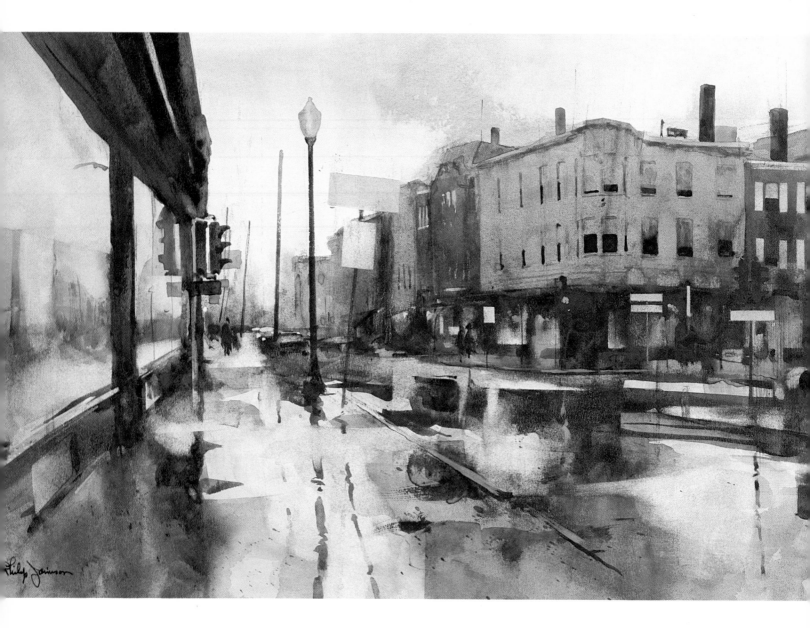

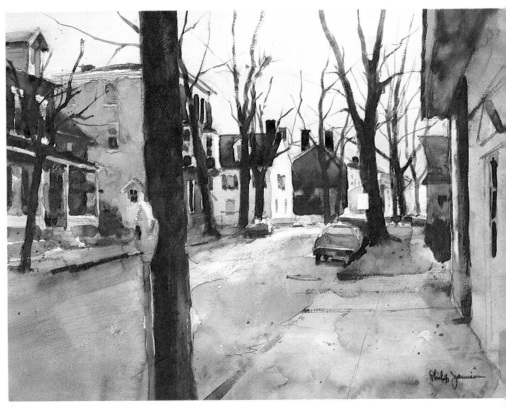

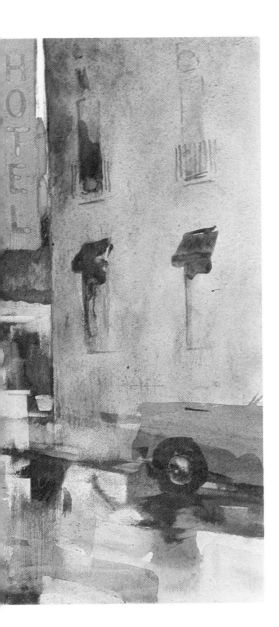

The Corner of Market and Church
(Left) Watercolor and charcoal
13″ x 27″ (33 x 68.6 cm)
Collection of Mr. and Mrs.
David J. Knauer

I painted this intersection of my home town, West Chester, Pennsylvania, about 1965. Elements such as the delicate street lamps and an elegant hotel, a wall of which is suggested on the right, have since been torn down in the name of progress and are now only memories. I incorporated charcoal into this painting along with the watercolor. Like many of my urban scenes, it is depicted on a rainy day—not because I love only rainy days, but rather because the wetness helps me produce a composition more to my way of thinking. The stark, sometimes clumsy shapes of the streets often overpower the jewellike qualities of the buildings that interest me so much when I paint urban scenes. By using rain as a foil, I can eliminate the street as a "street" and employ it instead as a mirror that repeats the patterns of the buildings. This way I not only arrive at a much more exciting composition but also have much more malleable shapes with which to work. The end result is a painting, rather than merely a picture of a street.

Miner and Church (above)
Watercolor
8¾″ x 11¾″ (22.2 x 29.9 cm)
Collection of Mr. and Mrs.
Edward J. Cotter

This street scene, painted in late afternoon as the sun was starting to go down, shows some of the strong architectural features of my home town, West Chester, Pennsylvania. I played the cool grays of the foreground and buildings against the warmth of the sky, using the stark vertical of the dark telephone pole to break up an otherwise mundane composition. It was painted quite directly, with little or no reworking, on a thin 72-pound cold-pressed paper.

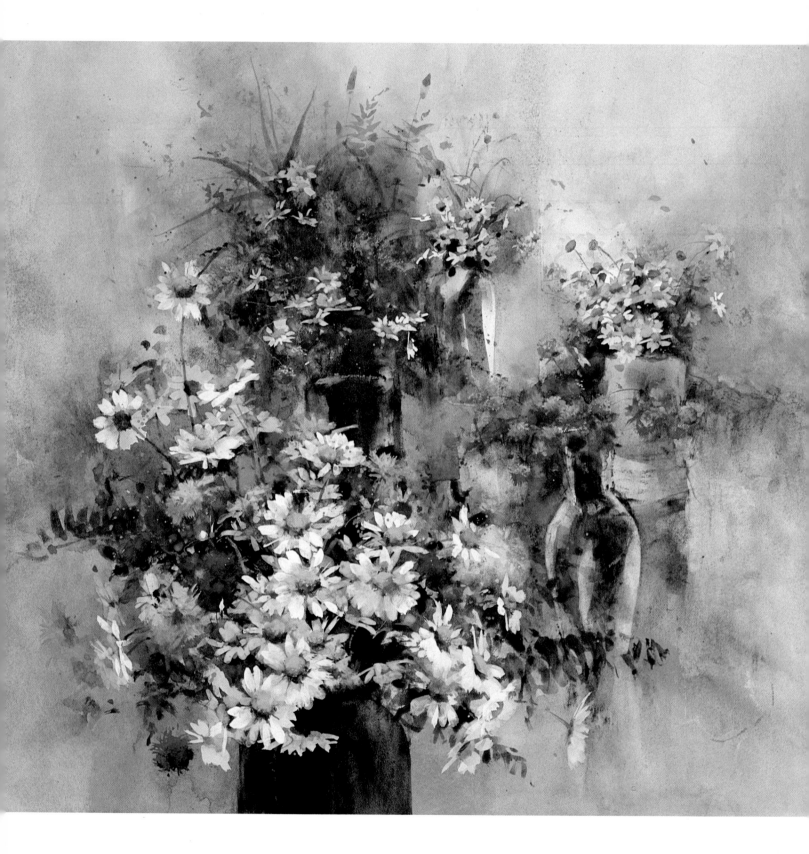

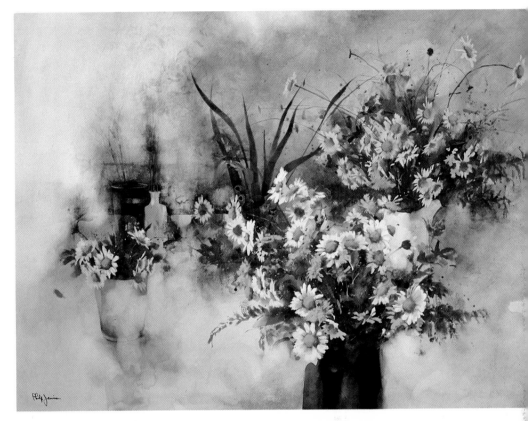

June Flowers (left)
Watercolor
19¼″ x 29″ (48.9 x 73.7 cm)
Collection of Mr. and Mrs.
Earl H. Reese

This is an extension of some of my smaller flower paintings in which I am primarily interested in two things: the flowers themselves, and forming an esthetically pleasing arrangement in space with them. To do this I completely eliminated any suggestion of the room or surroundings and concentrated solely on the flowers.

Last Summer (above)
Watercolor
21″ x 29″ (53.3 x 73.7 cm)
Courtesy New York
Graphic Society

Last Summer began as a very different concept from what appears here. Originally I had planned and painted it as an interior view of my studio with a number of vases of flowers scattered around. But the painting seemed much too confusing, so I proceeded to eliminate various elements. Almost everything suggesting a room vanished completely, including a window, a wall, and a table. Even some of the flowers disappeared in the process. The resulting painting, although far removed from my initial idea, proved to be much more gratifying and esthetically pleasing.

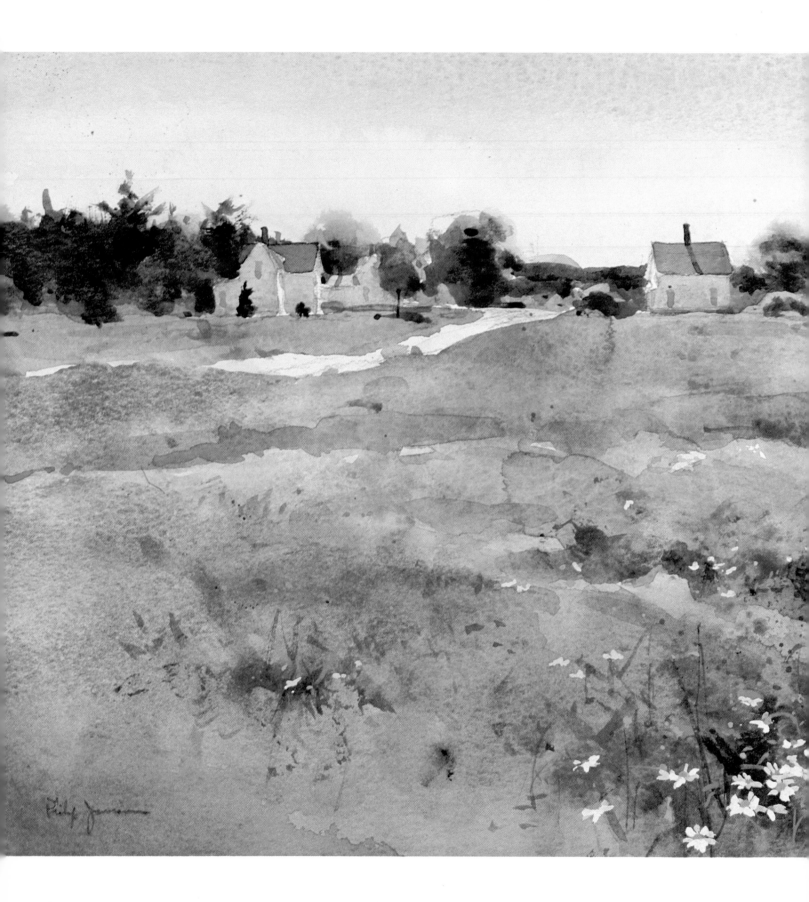

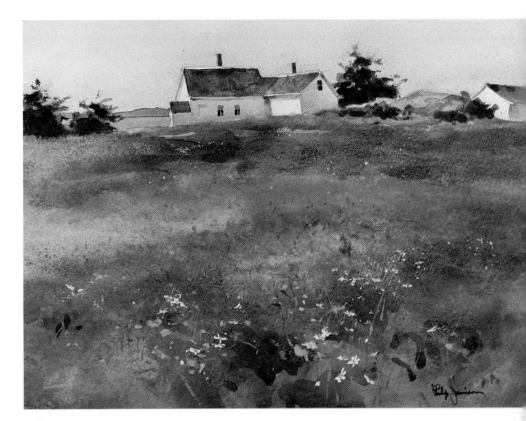

Island Houses (left)
Watercolor
10⅜″ x 14¾″ (26.4 x 37.5 cm)

This is the view from the yard of one of America's best-known living painters, Raphael Soyer. His house is just a stone's throw from ours, so I pass it nearly every day. I often marvel at the variety and colors of the grasses that grow here, and on this summer day the fields fairly shimmered in the sunlight. That's what I tried to capture. It is one of the most spontaneous watercolors I have ever done.

The Milk Farm (above)
Watercolor
10″ x 13¾″ (25.4 x 34.9 cm)

This is a sunny morning view of a typical island home. Often as I drove by this farm my eye would be caught by the pattern of the sun on the house and the tremendous warmth of the grassy field. Quite frankly, I delayed painting it because I wasn't sure how to do it. Now that I have completed this small watercolor, I am certain that I shall return to paint the farm again.

Frame House
Watercolor
10″ x 15″ (25.4 x 38.1 cm)
Collection of Mr. and Mrs.
William B. Haines, Jr.

The subject of this painting is the same little tenant house depicted in Along Hillsdale Road. Here, because the snow covers the winter grasses, the scene appears much more stark. This painting is one of my freshest, most directly painted efforts with pure, transparent watercolor. Done in a fairly wet technique, the picture implies more detail than it actually has.

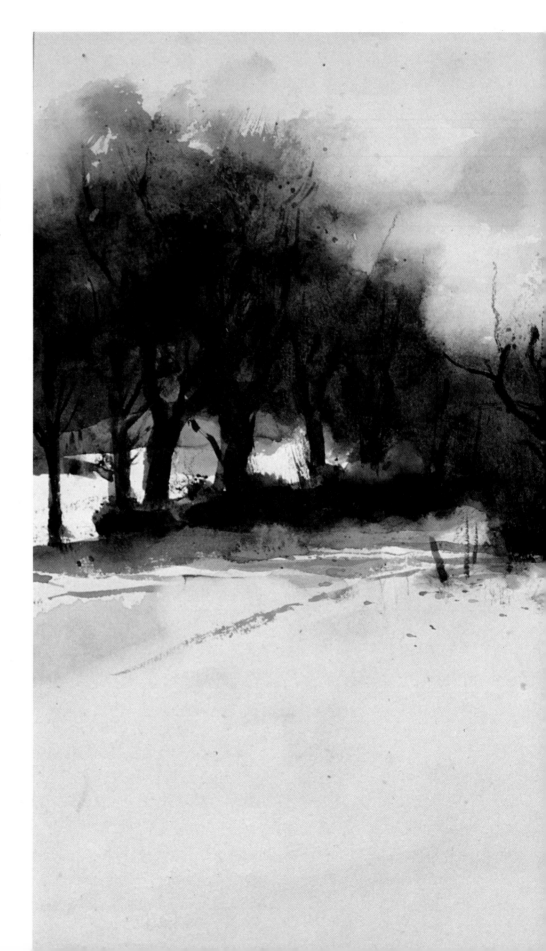

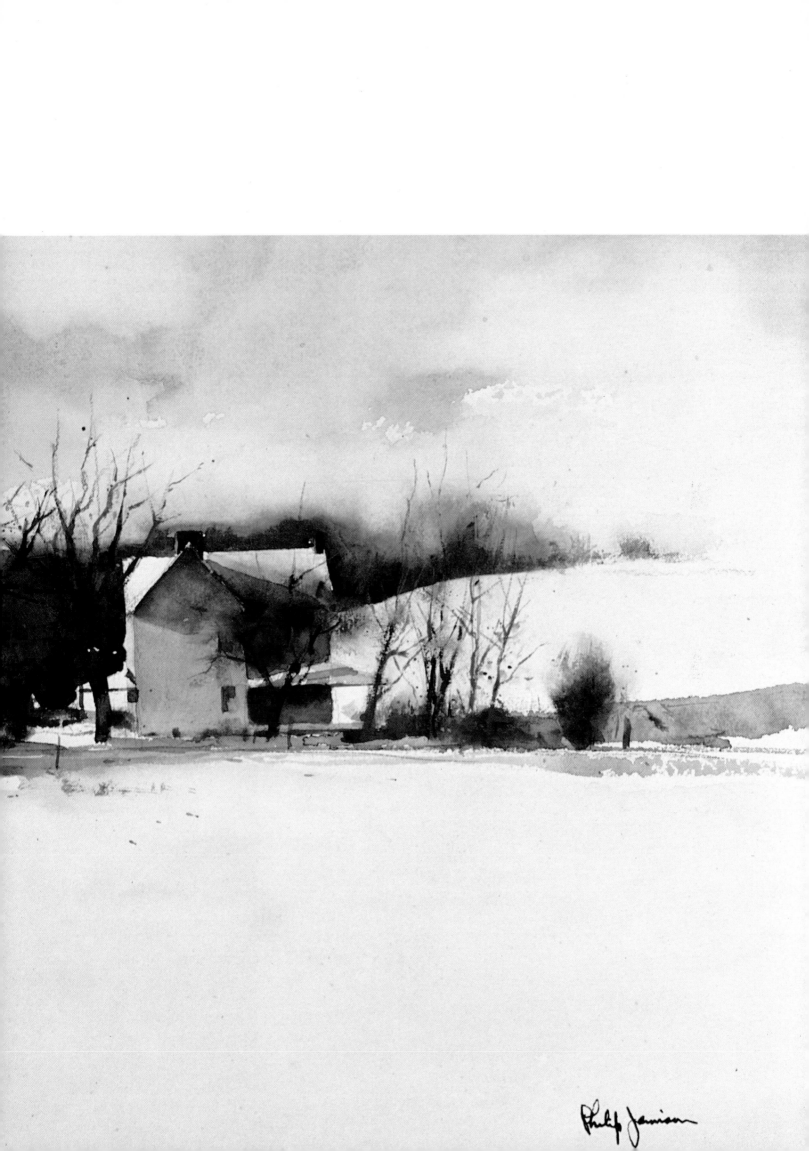

Philip Jamison

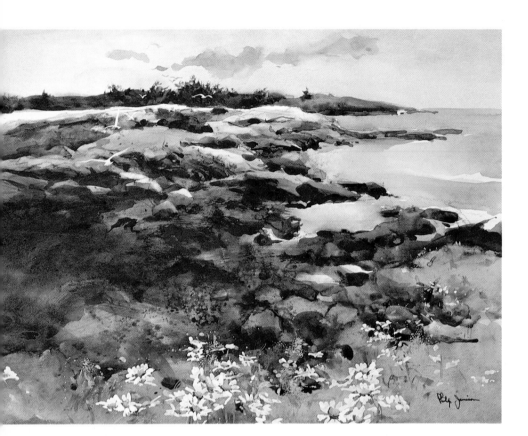

Grimes Point Rocks (above)
Watercolor
14¼″ x 19¼″ (36.2 x 48.9 cm)

In late afternoon my wife, Jane, and I often walk down to Grimes Point at low tide and go rock hopping while waiting to see the ferry arrive. The small green island in the distance is Potato Island. Beyond that is Lane's Island, where my Uncle Ed and Aunt Janet lived. I interjected the daisies at the bottom as an afterthought, to add a little liveliness to the painting. Sometimes additions such as this can end up being corny, "too much for the money," or just plain disastrous. I left the daisies there anyway.

Maine Marshland (right)
Watercolor
10½″ x 14¾″ (26.7 x 37.5 cm)

This painting represents one of those times when most everything goes right. It was done rapidly and required almost no changes. While I don't consider it an "important" painting, to me it has pleasing color relationships and employs some of the free, wet, and pleasant qualities that belong to watercolor alone.

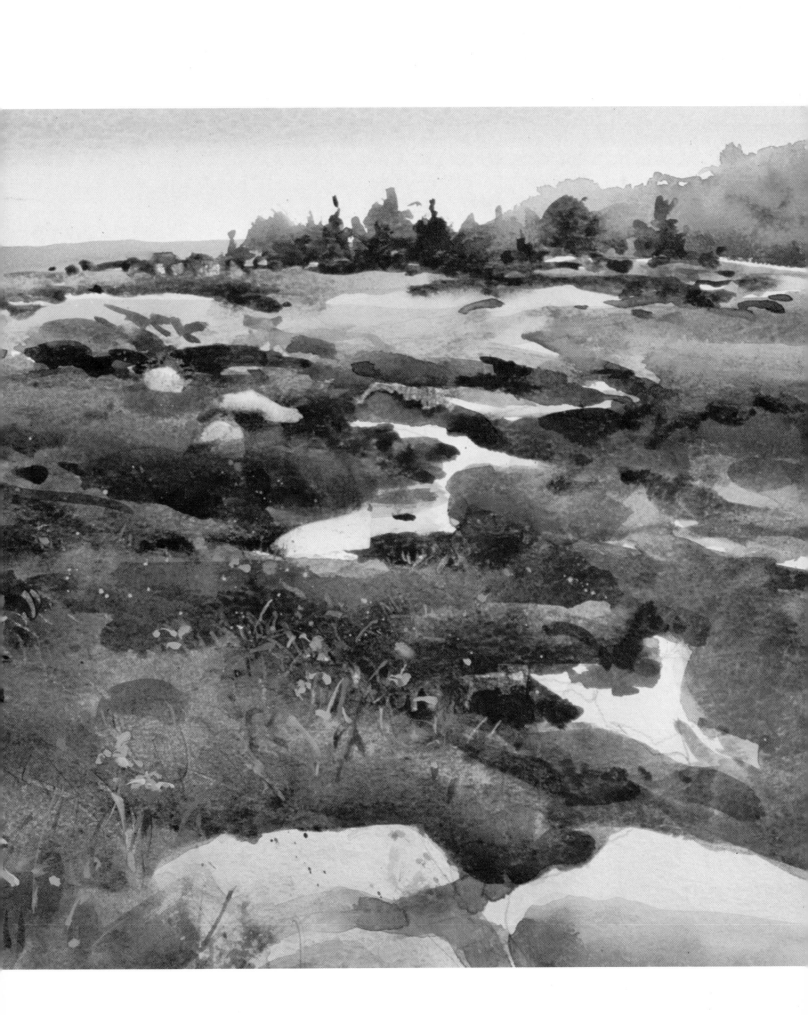

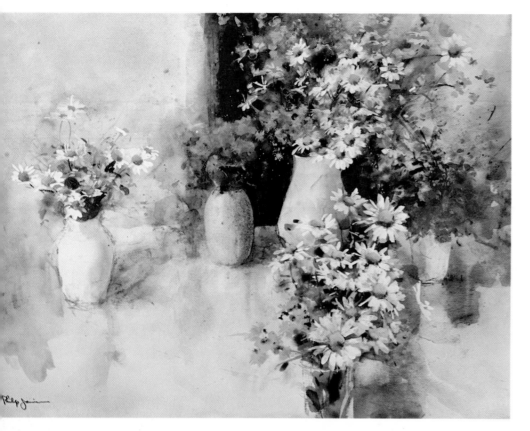

Island Still Life (above)
Watercolor
14¼″ x 19½″ (36.2 x 49.5 cm)
Collection of Mr. and Mrs.
Robert W. Jones

This multiple-vase still life was painted in my Maine studio. I made little attempt to "arrange" the flowers and did not even alter the placement of the vases on the table. I simply began to paint them as they were. In order to create a flow or feeling of movement through the painting, I added and subtracted flowers as I saw fit. I spent a great amount of time dealing with the large negative areas surrounding the flowers. These shapes and values were constantly revised as the painting progressed.

Island Flowers (right)
Watercolor
13½″ x 19½″ (34.3 x 49.5 cm)
Courtesy of Aaron Ashley, Inc.

This watercolor is one of the first in which I painted multiple vases of flowers. It came about quite naturally because my studio in Maine is usually overflowing with vases of flowers. Here, as in most of my flower paintings, you can see that some areas were painted very directly, while others have been worked over and over. Surprisingly, it is often the plainest area, such as the simply suggested white vase, that has been worked over the most.

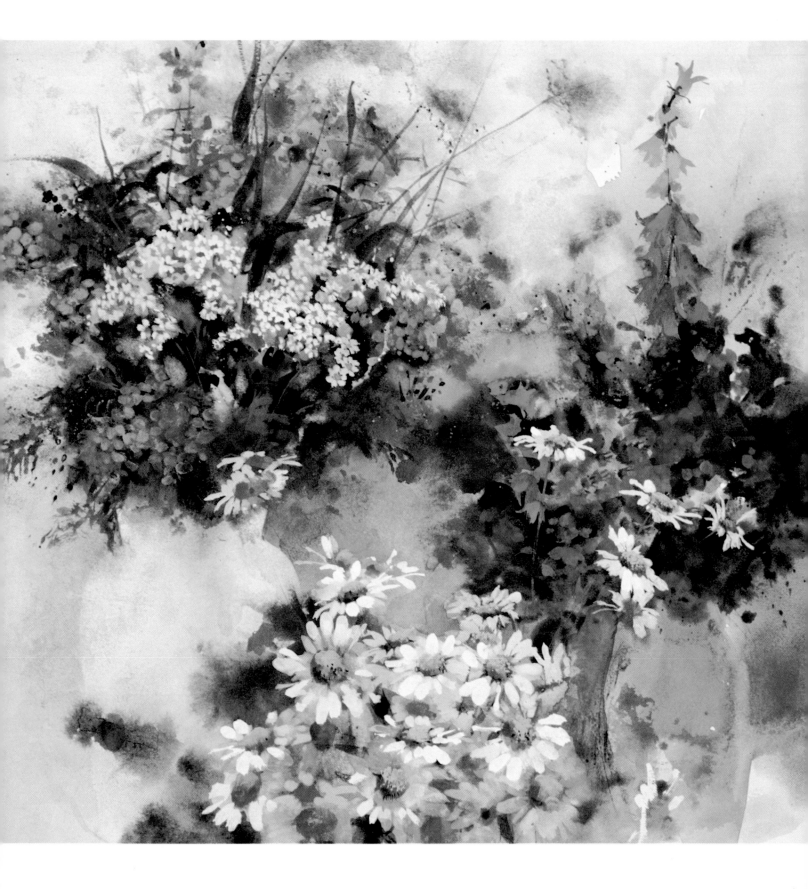

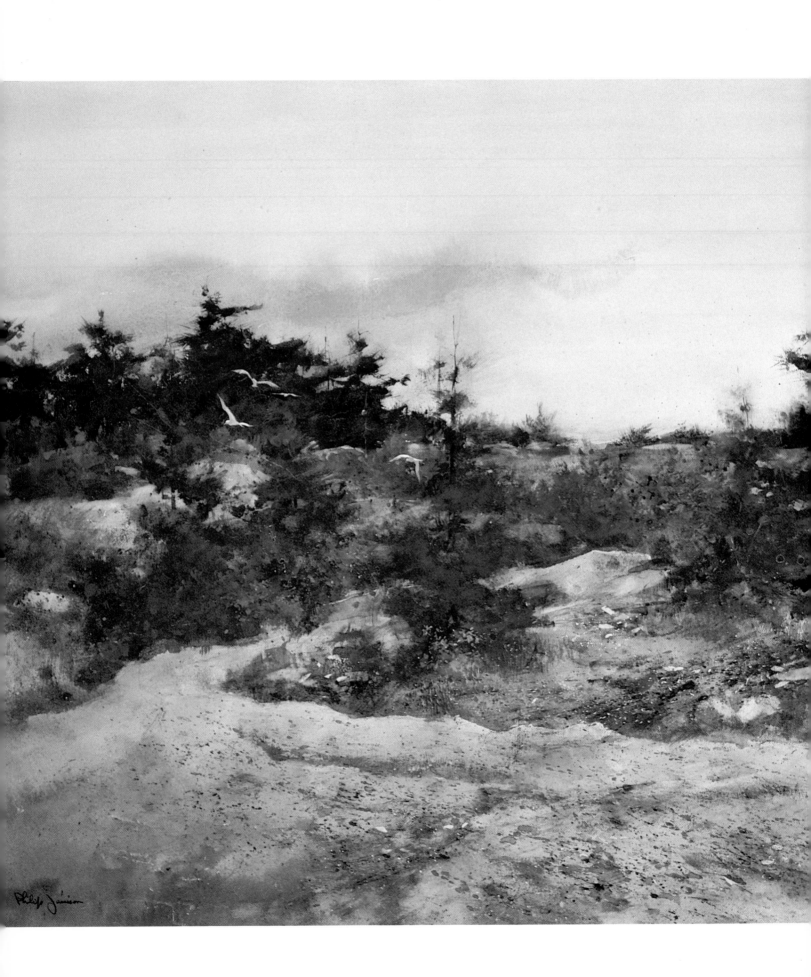

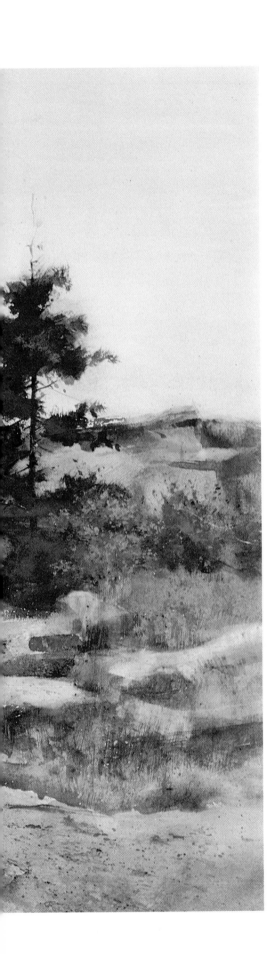

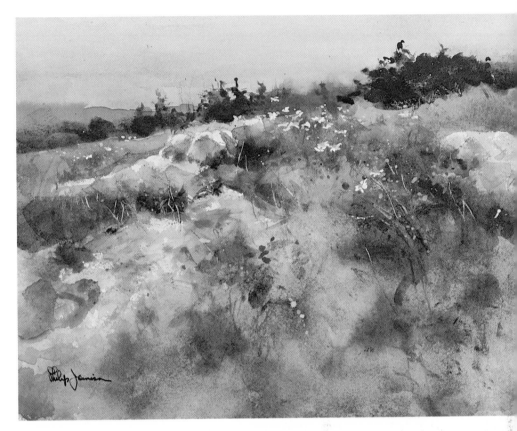

Ducky's Land (left)
Watercolor
20¾″ x 28¾″ (52.7 x 73 cm)

My closest friend on Vinalhaven is Ducky Haskell, a native of the island. This painting shows a piece of land that was handed down to him through his family. In bygone years the island was one of the major sources of granite for buildings on the East Coast. But as the years passed, the cost of transporting the stone to the mainland increased so significantly that the industry disappeared. This is one of the quarries that was stripped bare to the stone; as can be seen here, grasses and trees have again begun to cover the rocky skeleton.

A Stand of Daisies (above)
Watercolor
8½″ x 11½″ (21.6 x 29.2 cm)

On an afternoon walk through a summer field, I came upon these daisies poking their heads through the tawny grasses. They seemed so small and insignificant, and at the same time, so important. And so it is with the painting; it too is small and unassuming— yet, sometimes I wonder.

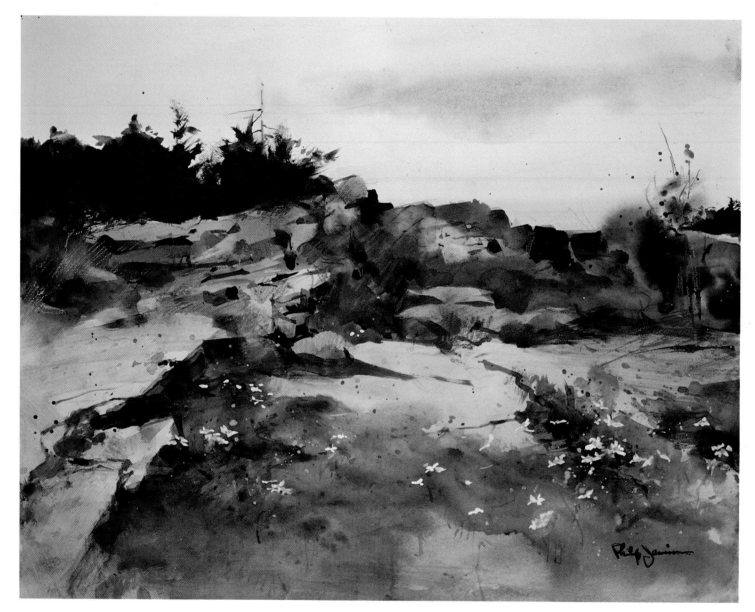

Quarry Ledges
Watercolor
10½" x 14" (26.7 x 35.6 cm)

From start to finish, this little watercolor took a full sixteen years to complete! Most of it was painted outdoors during the first sitting in 1963; however, it just didn't seem to "jell." I considered it many times during the intervening years, until at last I decided to rework the foreground. I transformed the formerly flat,

rocky foreground into a grassy area spotted with daisies. This helped pull the composition together and immensely improved the overall color. I find that working on paintings over a long period of time is increasingly the rule, rather than the exception, in my work.

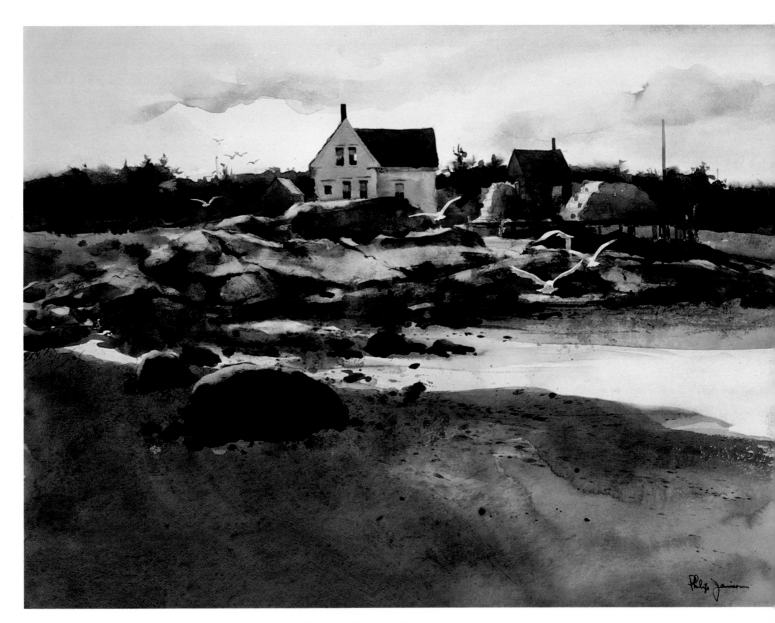

Gulls at Anthony's Place
Watercolor
14½″ x 19½″ (36.8 x 49.5 cm)

It has been my custom of late to do a series of paintings on one subject, as I did with Farm on Frank Road, *page 85. This typical Maine lobsterman's house and fish house sitting on the edge of the water is a subject I have painted often, in its many moods (see Demonstration of Anthony's Fish House, page 50). This painting shows it from the muddy clam flats at low tide, just* before the sun rises overhead. Here, as in most of my watercolors, I took many liberties, greatly simplifying the foreground to enhance and complement the busyness of the central strip. The cloud formation, although it seems to have been painted very casually and quickly, was quite deliberately planned.

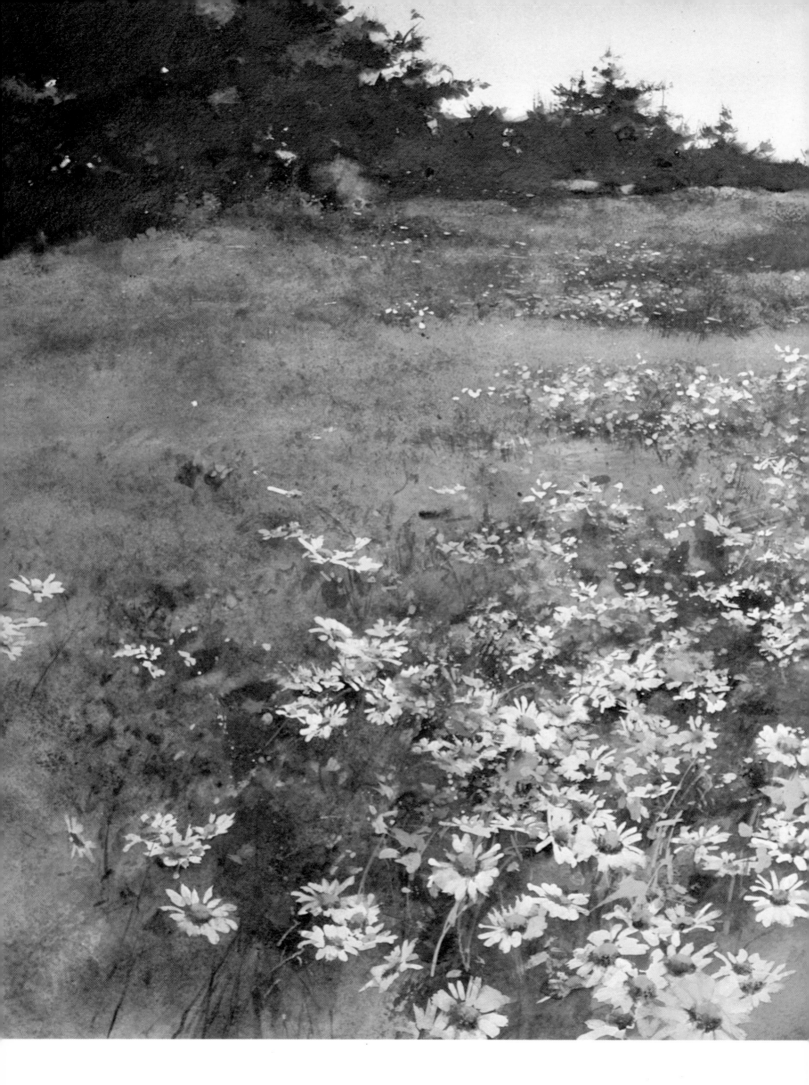

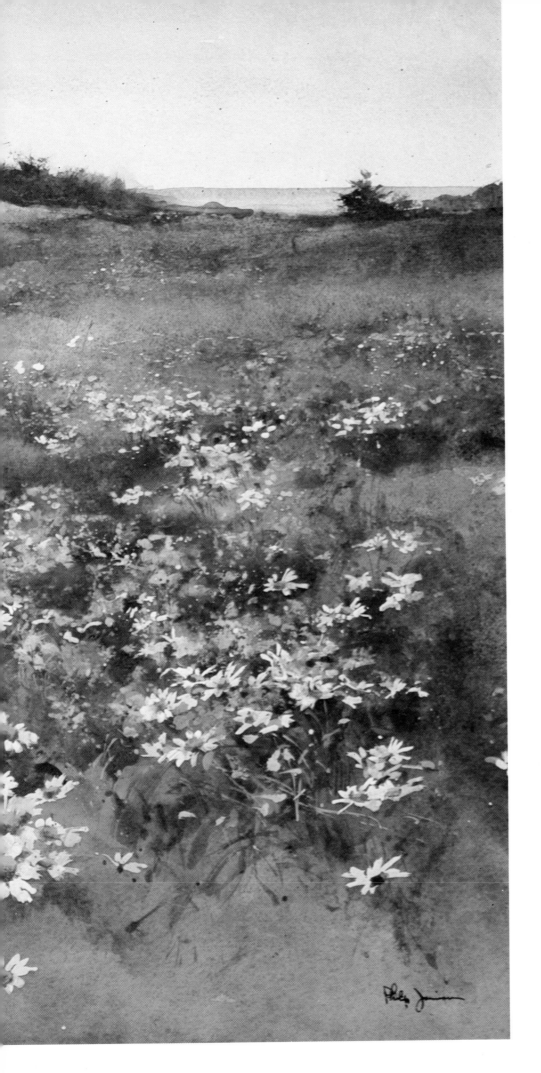

Summer Field
Watercolor
20½″ x 28¼″ (52.1 x 71.8 cm)

*In June the Maine fields come
alive with daisies announcing the
beginning of summer. This paint-
ing is a composite view, done from
memory, of the many fields I have
seen over the years.*

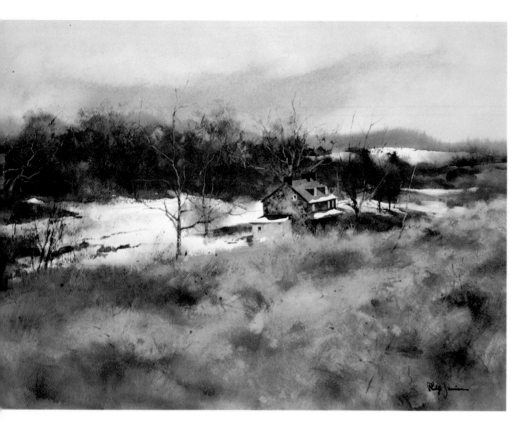

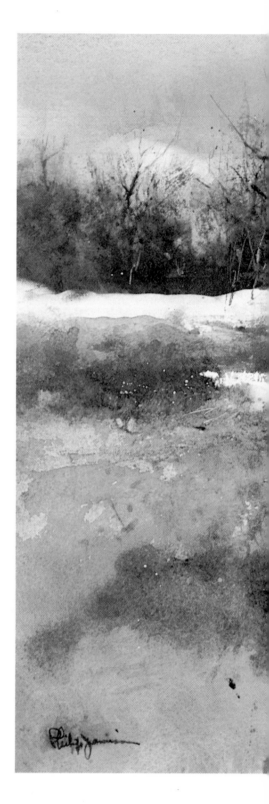

Willistown Farmhouse (above)
Watercolor
13¾″ x 19¾″ (34.9 x 50.2 cm)

This fieldstone farmhouse is typical of the early homes in Chester County, Pennsylvania, with eighteen-inch-thick walls constructed entirely of stones that had been turned over in the surrounding fields. Perhaps that is why these houses blend in so well with the landscape. This one nestles serenely in a cozy valley, but about a hundred yards away is a newly created, traffic-congested highway. As I tramped over the field shown in the foreground, I was struck by the need to preserve our beautiful open land and the hand-fashioned architecture of the past.

Farm on 401 (right)
Watercolor
13¾″ x 21¾″ (34.9 x 55.3 cm)
Collection of Mr. and Mrs.
George T. Workman

I had passed this farm on a number of occasions but was unable to decide just how I wanted to paint it, as its appearance and mood seemed to change markedly with the weather. Then one day when the ground was wet with melting snow and the heavy clouds hung low overhead, I saw what I wanted. The air just above the ground seemed clear, but the trapped moisture from previous snows had strengthened all of the earthen colors to such a degree that the scene formed a decidedly strong light and dark pattern. But the painting did not go easily for me; I struggled over this watercolor for a long time before arriving at a statement that finally satisfied me.

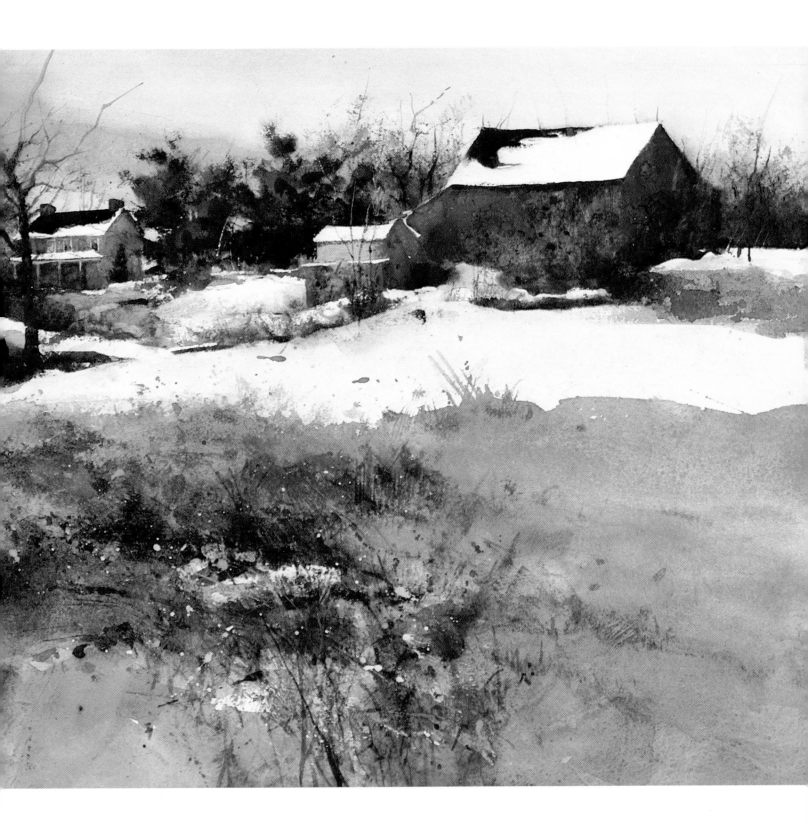

Index

Edited by Betty Vera
Designed by Bob Fillie
Set in 12 point Melior
Graphic production
 by Hector Campbell